WHAT A PICTURE!

WHAT A PICTURE!

PHOTOGRAPHS OF THE 30s & 40s BY REGGIE 'SCOOP' SPELLER

EDITED BY MARY DUNKIN

Contents

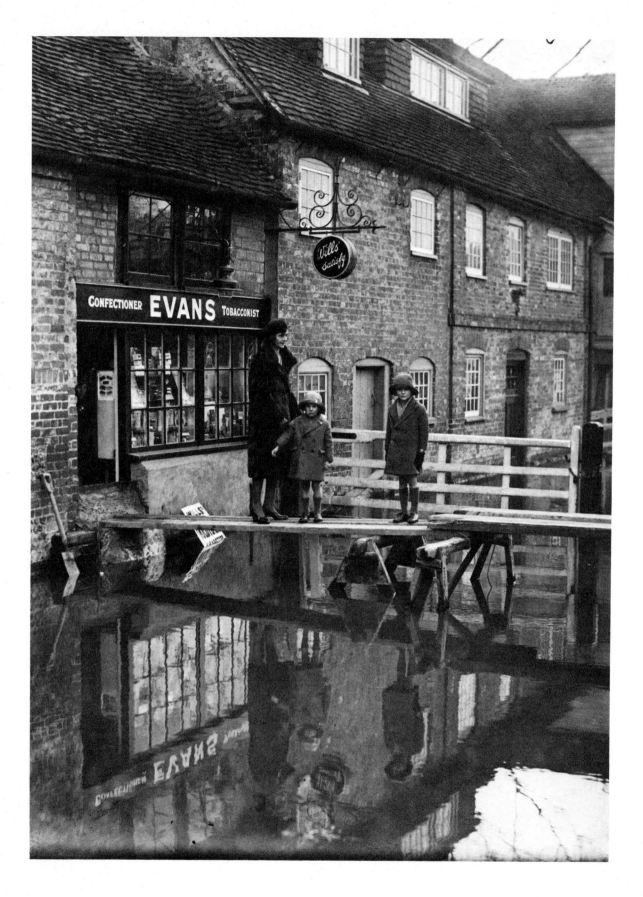

Introduction

Reggie 'Scoop' Speller's career as a Fleet Street photographer spanned six decades. When he began working at the age of sixteen the First World War had just started and he retired 20 years after the end of the Second World War. His job as a staff photographer for agencies producing pictures for popular newspapers and magazines took him out on thousands of assignments ranging from the tragic to the ridiculous. This book is a selection of his best pictures which were almost all taken in the Thirties and Forties. While it does not pretend to be a comprehensive account of the times it does reflect an extraordinary range of English experiences and attitudes as well as the achievement and personality of an outstanding press photographer.

Speller was never famous with the general public (few press photographers are) but such was his technical proficiency and flamboyant character that he became almost legendary among his colleagues and competitors. He had that special mixture of initiative, luck, charm and sheer cheek which lifted him out of the general run. He was not afraid to ask prime ministers to wave yet again or kings to pose just a little longer and he was well aware that hanging around, after competitors had rushed back to Fleet Street, might sometimes make the difference between an ordinary picture and a special one. On one occasion Speller, in the company of many others, was sent to photograph King George VI and Queen Elizabeth inspecting bomb damage at Buckingham Palace in 1940. When the others left, their stories complete, Speller had the feeling that he should stay on. Soon his persistence was rewarded: Winston Churchill emerged from the Palace to join the Royal couple. Speller asked if he could take a photograph of the three of them. They readily agreed and Speller had a 'scoop'.

He was an ebullient character. A colleague who worked with him for years said that he never once saw him 'down in the mouth'. He was a man perfectly equipped for a life where he needed to be on top form every day. He loved marshalling crowds, urging them to wave at the camera for him and he loved the photocalls where his forwardness as well as his strong sense of photographic composition was not only a personal boon but often a help to his competitors as well. As often as not they would put in the request 'Come on Reggie, pose the picture up.'

Of course the business of news photography fifty years ago was very different from today. Speller would travel from the offices of Fox Photos by public transport, weighed down with a cumbersome Goerz-Anschutz camera and a stash of heavy glass photographic plates. In those days the cameras had no range finders, no automatic light exposure meters and no synchronised flash. There was no fast film and the only means of 'focusing' was to judge the distance that you were away from the subject. All this is in stark contrast with the compact, highly automated cameras of today which allow the photographer to shoot 36 frames in a matter of seconds. Speller would have three or four attempts at getting a perfect picture and that was it.

The auguries for his career were good from the start; the very first photograph he took with a professional camera was a 'scoop'. As a sixteen-year-old seeking relief from his boring job in an animation studio, he went to Fleet Street and bought his first Goerz-Anschutz and after rudimentary instruction in its use from the salesman, he went straight along to Charing Cross station to take pictures of trains. When he arrived there he saw a man being stretchered into a waiting ambulance surrounded by flower girls throwing flowers. He took six shots and adjourned to a Lyons tea-shop in the Strand. There he fell into conversation with a man at his table who, quite by chance, worked for a picture agency and who realised that what Speller had taken were photographs of the first soldier returning wounded from the War. They rushed to the agency, developed the negatives and found a perfectly exposed picture. Speller was immediately employed by that agency, General Press Organisation, at a salary of £2 per week plus ten per cent commission. He stayed there until 1916 when he moved to Special Press.

By 1926, when Richard Fox, Ernie Beavor and Reg Salmon bought Special Press and renamed it Fox Photos, Speller was a seasoned

Left
7 September 1933
Heavy rains cause widespread flooding along the Thames. A visit to the sweet shop means a precarious walk across a makeshift bridge.

campaigner taking widely distributed pictures. It was a heyday for news photographers: the *Daily Sketch*, the *Graphic* and the *Daily Herald* used photographs extensively, the *Daily Express* had a special photo news section and the *Daily Mirror* had a centre spread which was all pictures. Especially popular with them were the 'feature photographs', a form of light-hearted posed picture virtually originated by Speller and Fox's picture editor, Stan Lauder, who would plan them a couple of weeks in advance. As is clear from the feature pictures section of this book (pp 41–45), most of them were highly contrived and involved beautiful girls or playful animals. Others looked more like news pictures. The photograph on page 42 is probably the most successful Speller ever took.

It did not bring Speller any personal fame because in common with all Fox photographs it was the name of the agency that was credited. Anonymity did not bother Speller. 'What', he says now, looking back on his career, 'is a name under a photograph? That doesn't count for much.'

If credits didn't matter to him, the quality of the prints of his photographs did and he would always take care to be at the picture editor's elbow to discuss the 'pull-ups', in other words, what part of the negative should be printed. This was important as pictures were not composed in frame on a Goerz-Anschutz. So the pull-up was almost as crucial as the original shot. And while some agencies sent their runner boys to the newspapers with prints that were still wet, in order to get a start on the opposition, Speller was always meticulous in seeing his prints and making sure that they were of a quality fit for release.

In the early days Fox Photos was a small outfit run quite informally. But in 1929, a messenger, Len Buckley (who still works at Fox Photos), suggested that they start a photographic library of their photographers' work. Fox is now one of the biggest photographic agencies in the world with a library of 800,000 negatives. In 1976 the library was valued at £500,000.

Today, Speller is in his eighties living in retirement in Eastbourne. He has been helpful in identifying and discussing photographs. While the captions in the book are mostly the original ones prepared by the agency at the time, he has supplied information about photographs whose captions have been lost and additional facts for many of the others. He remembers, often in considerable detail, the circumstances surrounding pictures he took over 50 years ago and he is still an enthusiast for the job he did for so long.

When he sees a photograph he likes, he doesn't reach for fancy adjectives. Most often he uses the phrase which is the title of this book: 'What a Picture!'

Sadly, during the preparation of this book, Reggie Speller died on 16 May 1981, and never saw its publication.

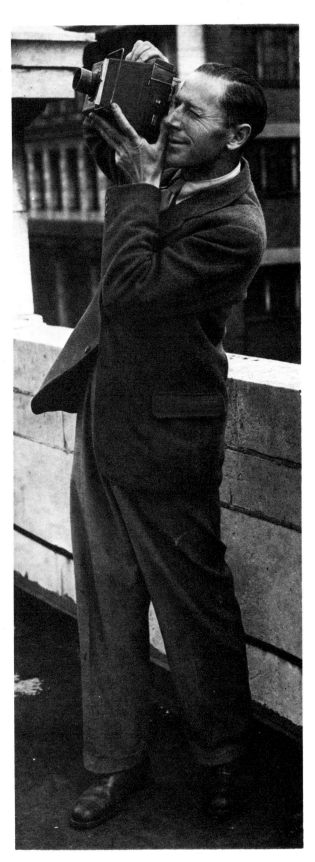

9 August 1946
Reggie Speller with his plate camera
on the roof of his photographic
agency – Fox Photos.

GOOD TIMES

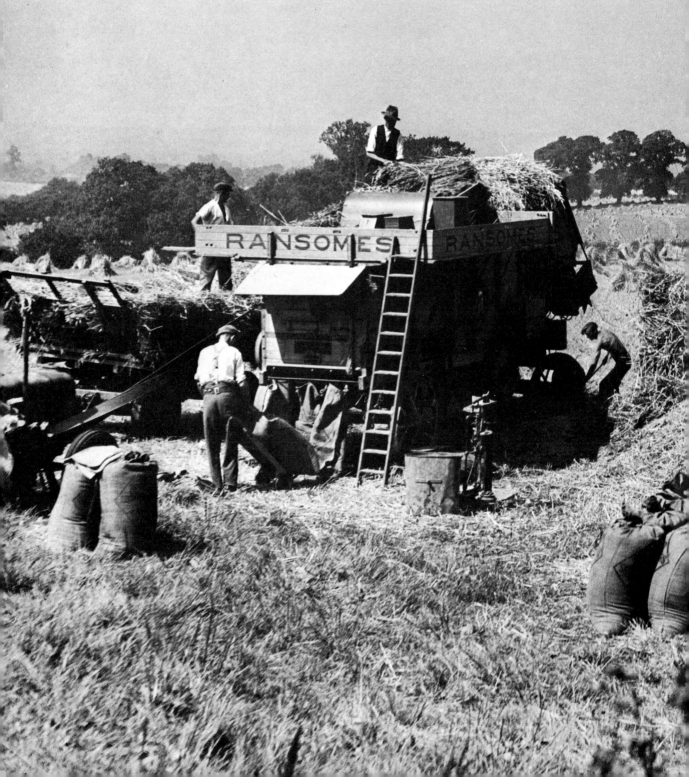

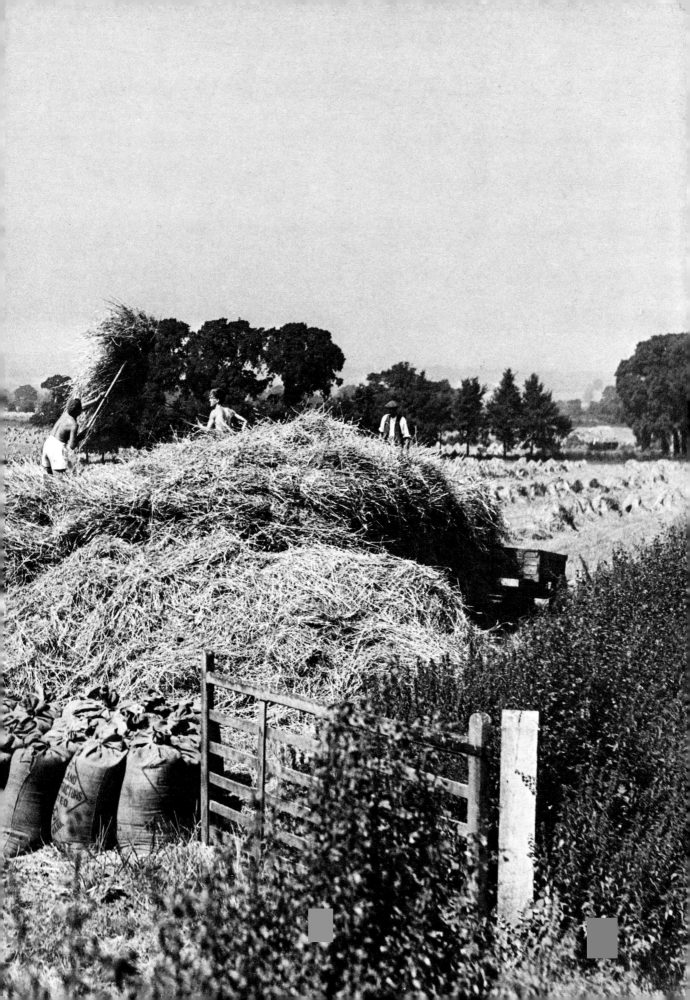

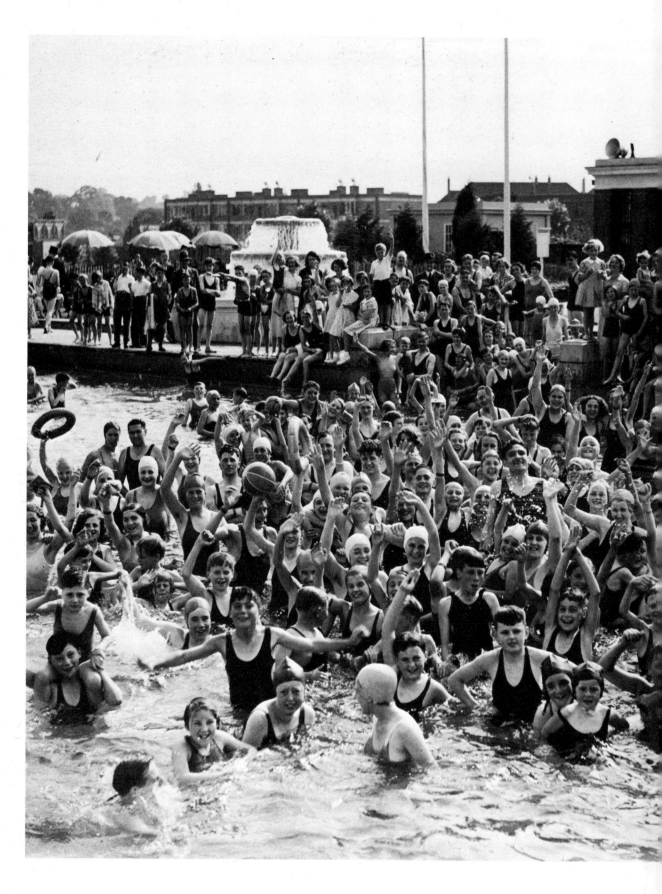

12

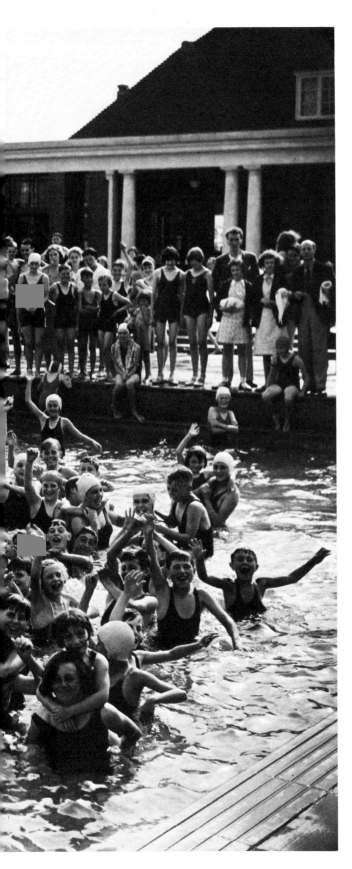

Fun and Games

Speller was equally at home photographing the aristocracy at Ascot and factory hands at Margate. He would be sent to cover all the big social events of the season: races, private views, balls and the like. Even at these formal occasions his eye for the unusual served him well. Mrs Baldwin, seen outside the Royal Academy, stands next to a policeman whose helmet echoes her hat's strange shape. Miss Ella Retford and Miss Dorothy Ward, embarrassed but game, run the gauntlet of the amused stares of a row of very ordinary picnickers.

Speller's sports pictures have a rare drama all the more striking when you consider the slow film and the heavy, unmanageable camera he used. They contrast utterly with the poses of the girls at the Chelsea Arts Ball. Speller was never ashamed of asking people to strike a pose for him – though he was just as happy to snatch a quick shot of an unsuspecting subject.

15 August 1936
The heatwave brought crowds to Finchley pool. By mid-afternoon over 3,000 people had taken to the water and were enjoying themselves.

Previous page
15 September 1938
Gathering the harvest at a farm on the Hog's Back, Surrey.

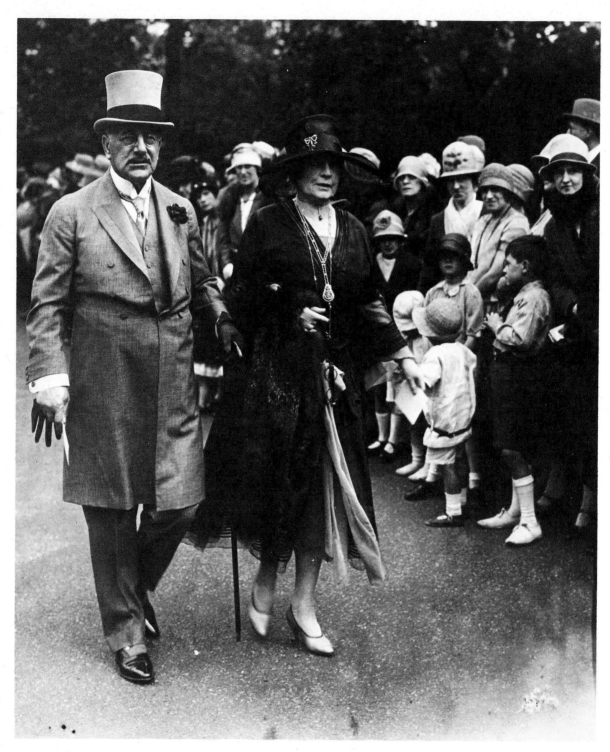

22 July 1926
Mr Alfred Mond, the industrialist
and politician who was knighted in
1928, and his wife arriving for a
garden party at Buckingham Palace.

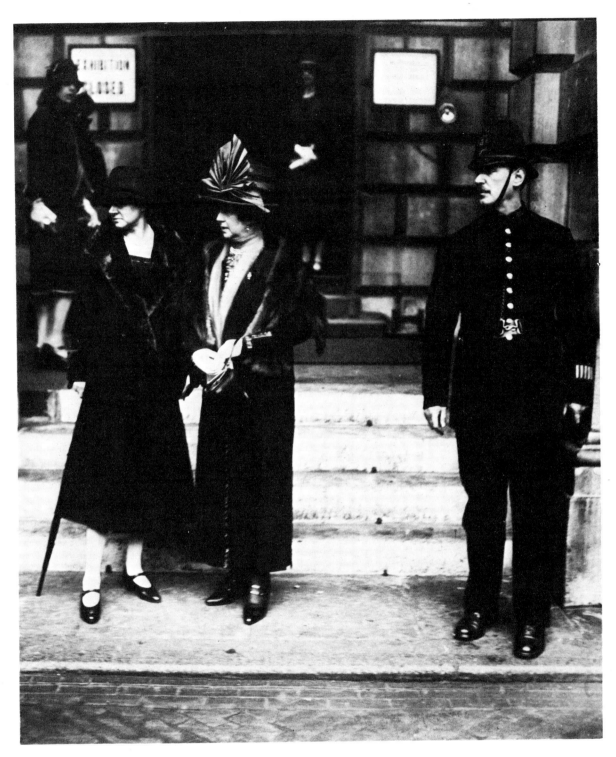

30 April 1926
Mrs Baldwin (centre), the Prime
Minister's wife, leaving the Royal
Academy of Art, after the Summer
Exhibition private view.

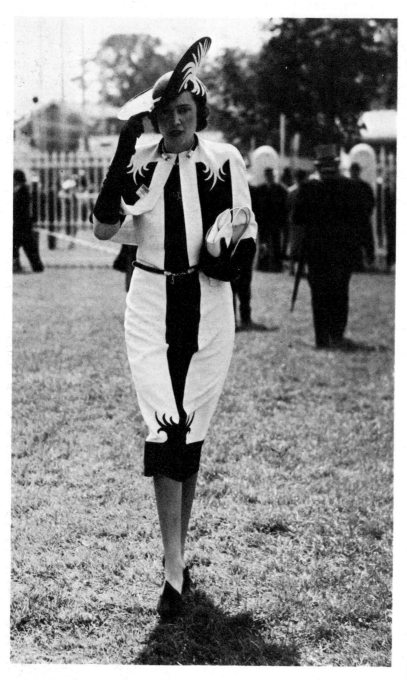

ROYAL ASCOT
14 June 1938
Mrs Bruce Webb, in an elegant black and white ensemble, arrives for a day's racing.

Right
17 June 1936
Miss Ella Retford and Miss Dorothy Ward provide an impromptu fashion parade for some alfresco lunchers.

Overleaf
18 June 1935
A well-known entertainer breaks from playing his accordion for a chat with racegoers.

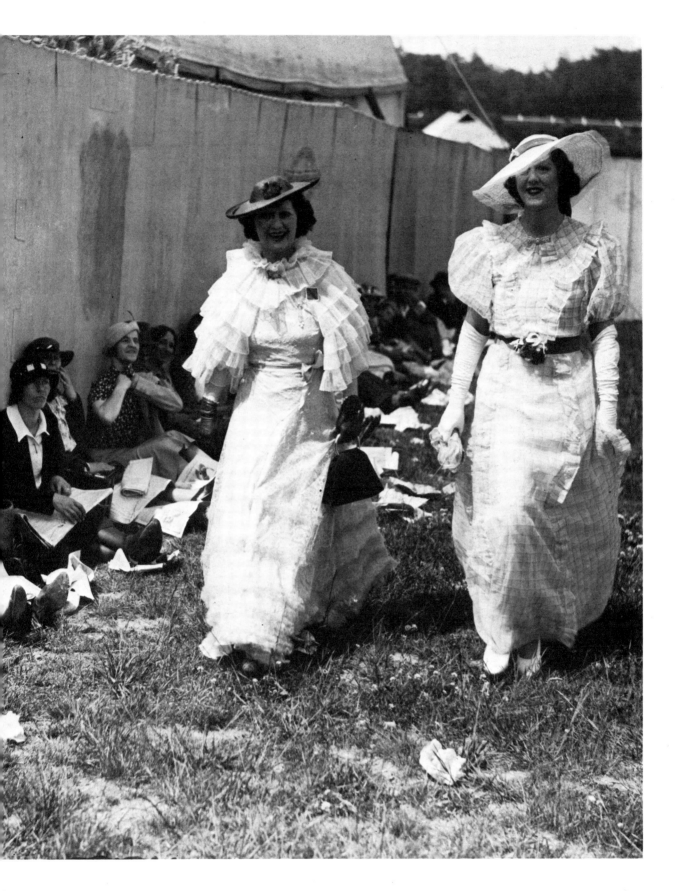

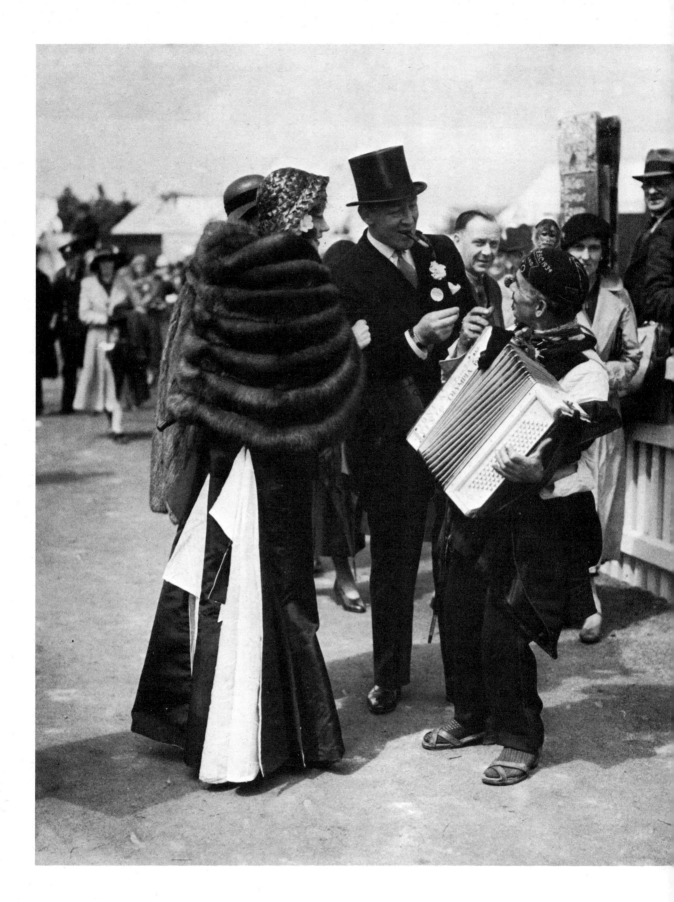

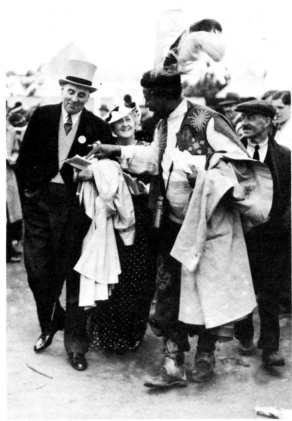

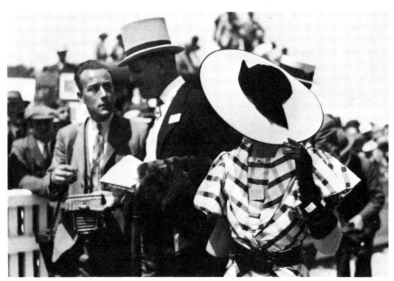

ROYAL ASCOT

Top
18 June 1935
Prince Monolulu, the well-known racing tipster giving advice.

Above
17 June 1936
Striking fashions seen on the course today. In the background, the photographer can be seen taking the racegoer's name for his newspaper.

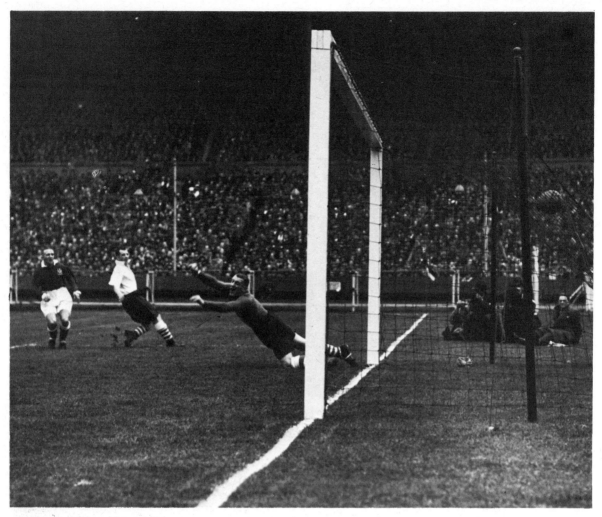

27 April 1935
The two finalists for the FA Cup at
Wembley Stadium were West
Bromwich Albion and Sheffield
Wednesday. Here Brown, the
Sheffield Wednesday goalkeeper,
makes a vain attempt to save a shot
from Boyes.

14 April 1934
An incident during this afternoon's
International between England and
Scotland at Wembley Stadium.

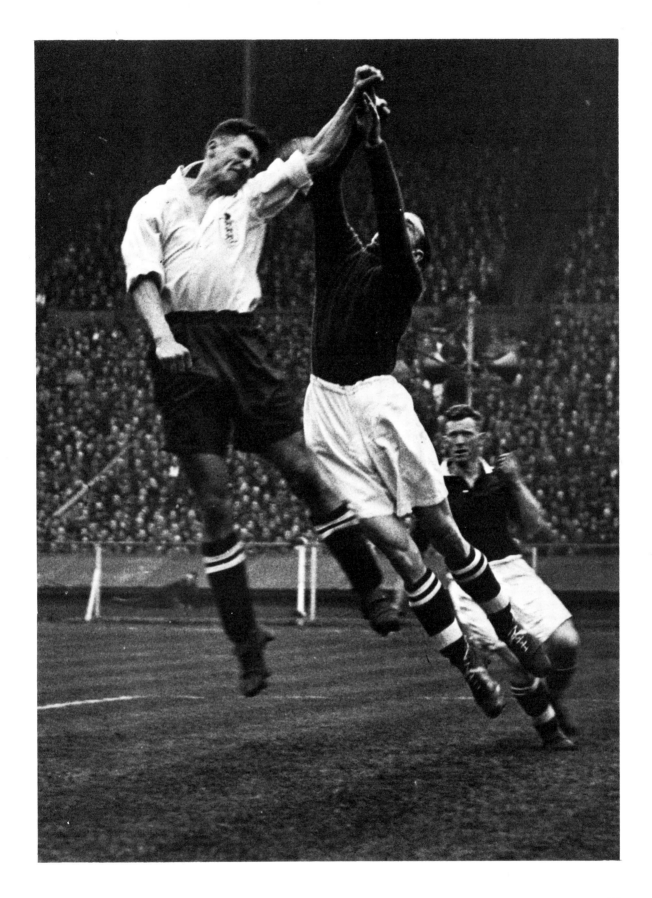

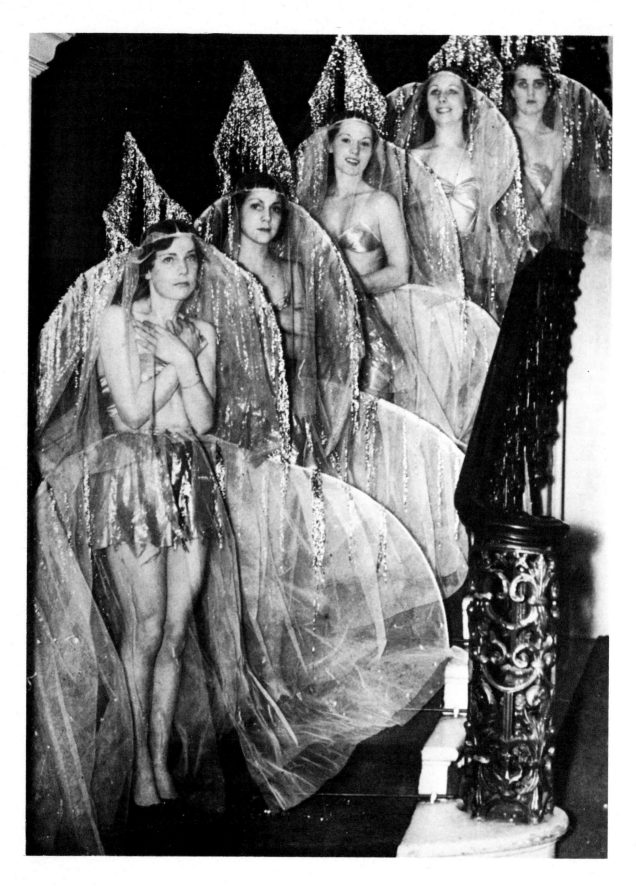

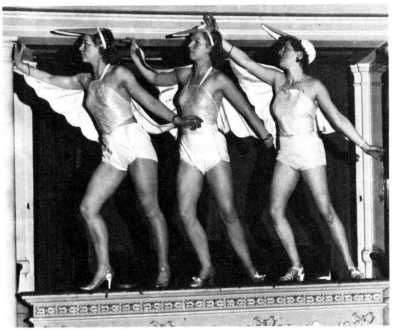

CHELSEA ARTS BALL
Opposite page
27 December 1936
Five lovely students, taking part in 'Water', made a striking picture descending the staircase. They had just finished rehearsing one of the tableaux, which will be seen at this year's Ball on New Year's eve. The theme is to be 'The Naked Truth'.

29 December 1934
A frieze of beautiful girls representing 'Speed' – one of the tableaux made by the students of the Slade School of Art – taken this afternoon during the final rehearsal.
Below
Students of the Westminster School of Art wearing some novel costumes – the evening dress of the future – which they designed for the Ball.

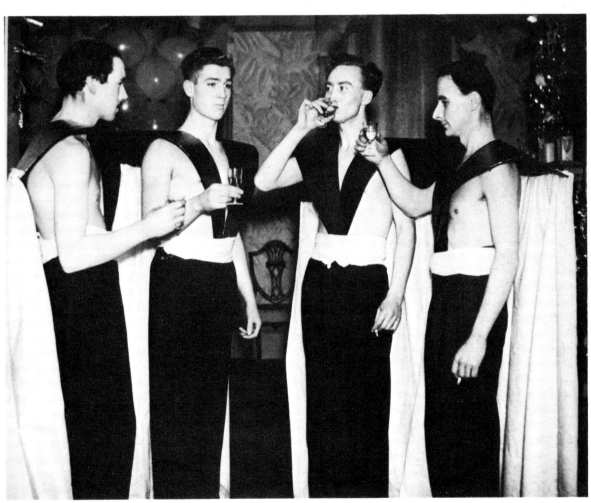

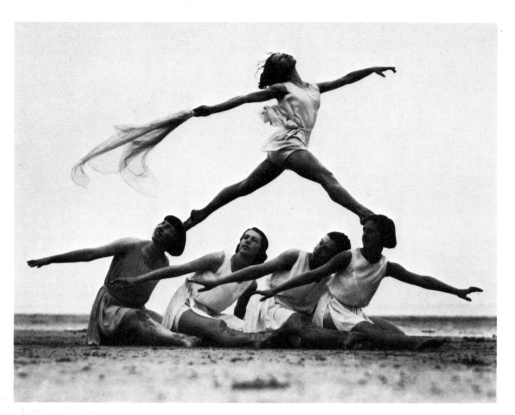

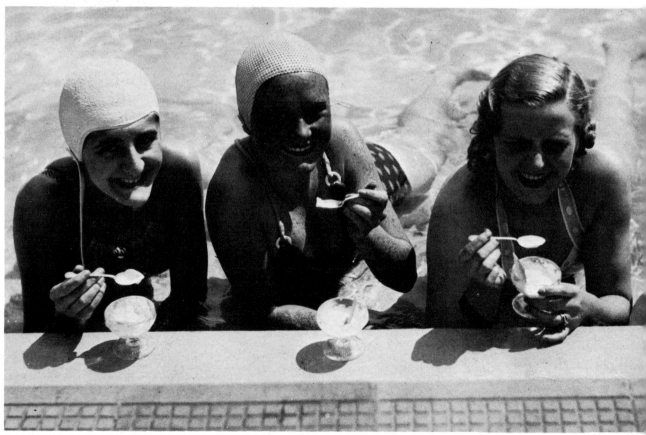

Opposite page
14 May 1934
Thanks to the unusually fine
weather – the best for years – pupils
of the Worthing School of Dancing
are having lessons in the open air.
Right
They take a break for relaxation.

Below
23 May 1936
This quartette of bathers at
Roehampton seem to be enjoying
life and have pretty good ideas on
comfort and coolness.

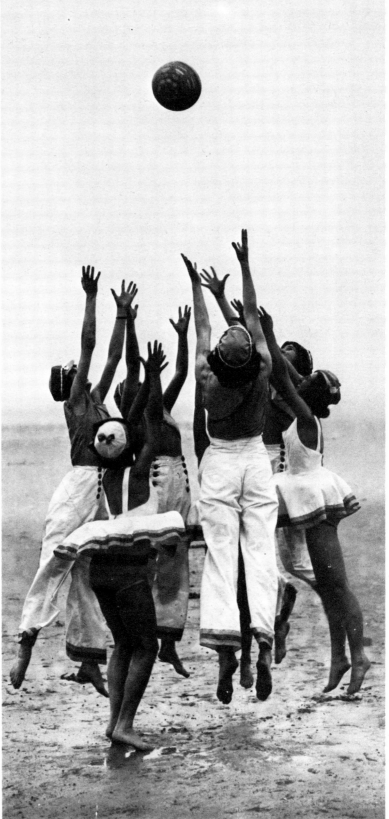

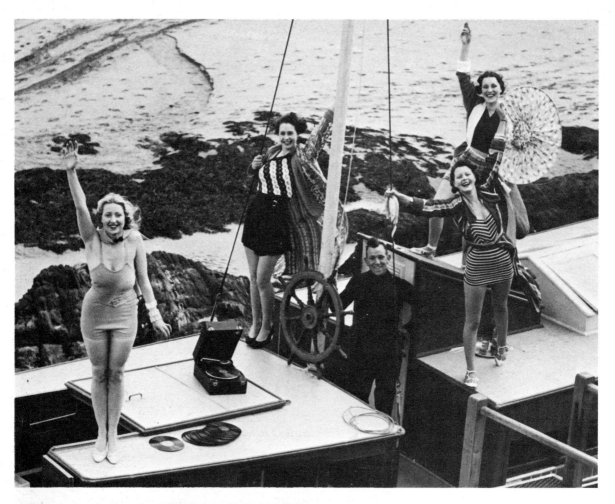

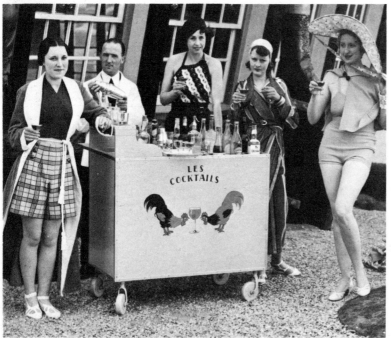

Above
22 April 1935
A novelty for those seeking a holiday with a difference: a complete boat has been set on the rocks and opened as a permanent annexe to a hotel at Burgh Island, on the South Devon coast.

Left
Drinking cocktails outside the main building of the hotel.

Opposite page
4 September 1934
The latest novelty for bathers is a large inflated cushion, which can be used for sunbathing on the beach, or for pleasure or sport afloat. 40,000 have been sold in England already, and the latest models are fitted with a sail. Here the workers who made them enjoy an outing to Margate.

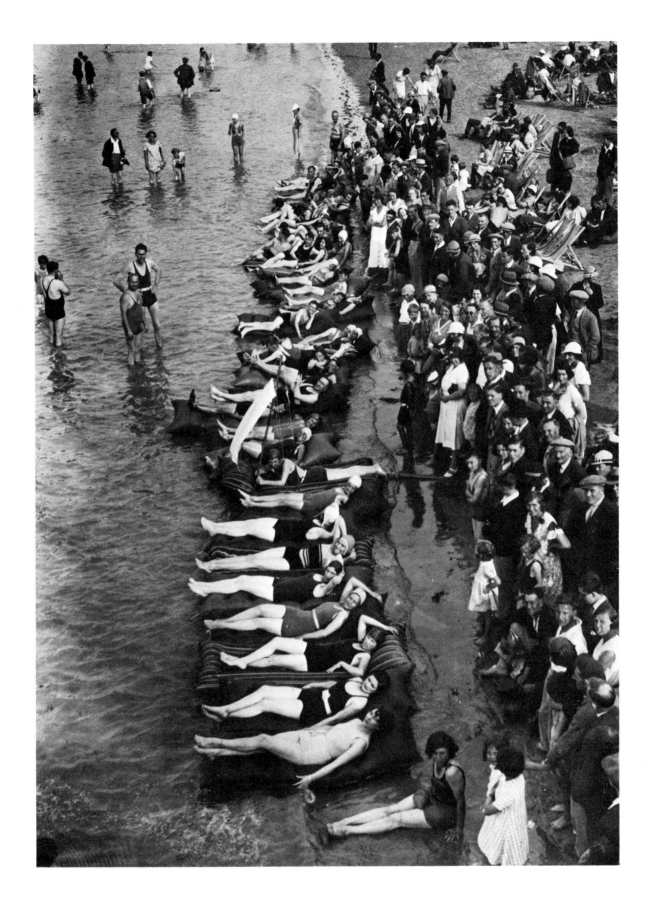

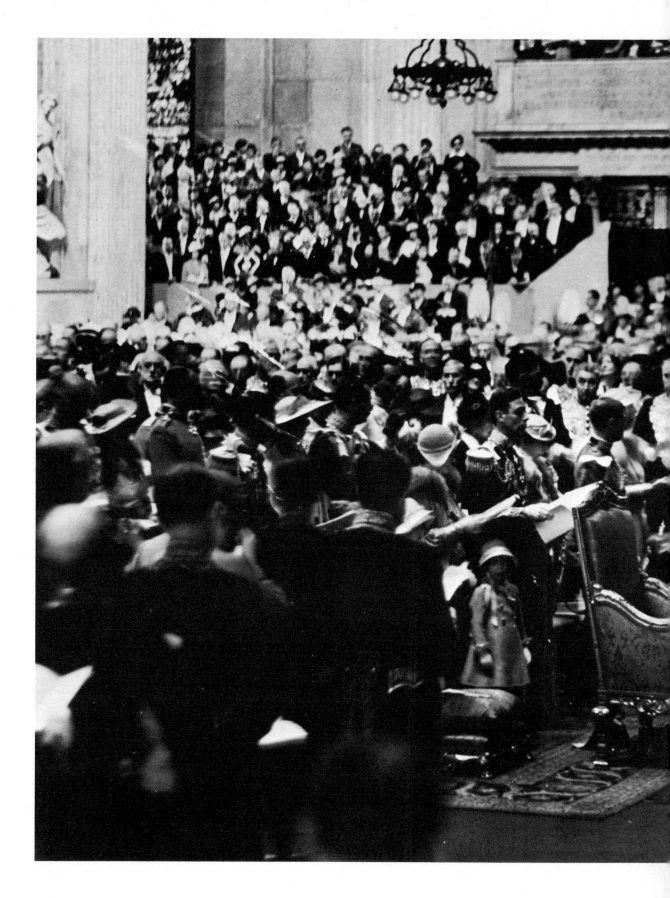

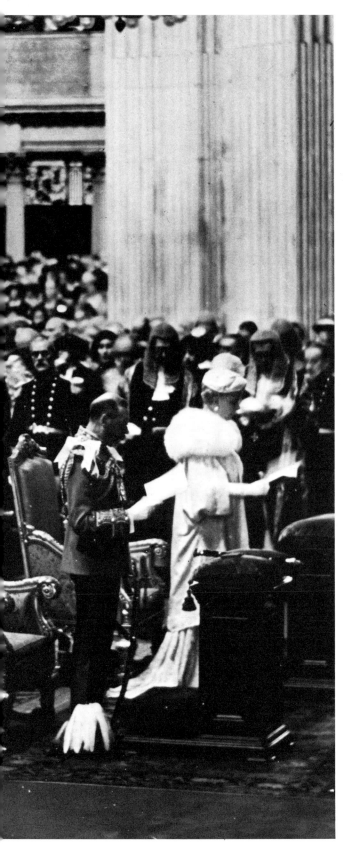

The Royal Family

Speller's eminence as a press photographer brought him to many state occasions. These were very awkward for photographers, who had to keep in the background and not disturb the ceremony. Even informal shots of royalty were subject to the constraints made by the Palace press secretary.

The grand set piece of the Silver Jubilee contrasts with the quick shot of the Duke of York (later George VI) at Wimbledon. The latter is startling to modern eyes: that face, familiar from millions of coins, going out to play tennis in public? The picture of Edward VIII at his father's funeral conveys, for all its grandeur, real sorrow.

The Duchess of York (now Queen Elizabeth the Queen Mother) has always been a perfect photographic subject. Her unforced smile was the same in 1936 as it is today.

Photographing the Duke and Duchess of Windsor after the abdication called for tact and delicacy. Speller managed, without offending the Royal Family, to satisfy the public's intense curiosity.

6 May 1935
The Silver Jubilee service for
George V and Queen Mary at
St Paul's Cathedral.
(When this picture was published, a
member of the public wrote to the
Archbishop of Canterbury
expressing disgust at the presence of
photographers on so solemn an
occasion. He replied that their
behaviour had been exemplary and
that Mr Speller's photographs were
'beautiful'.)

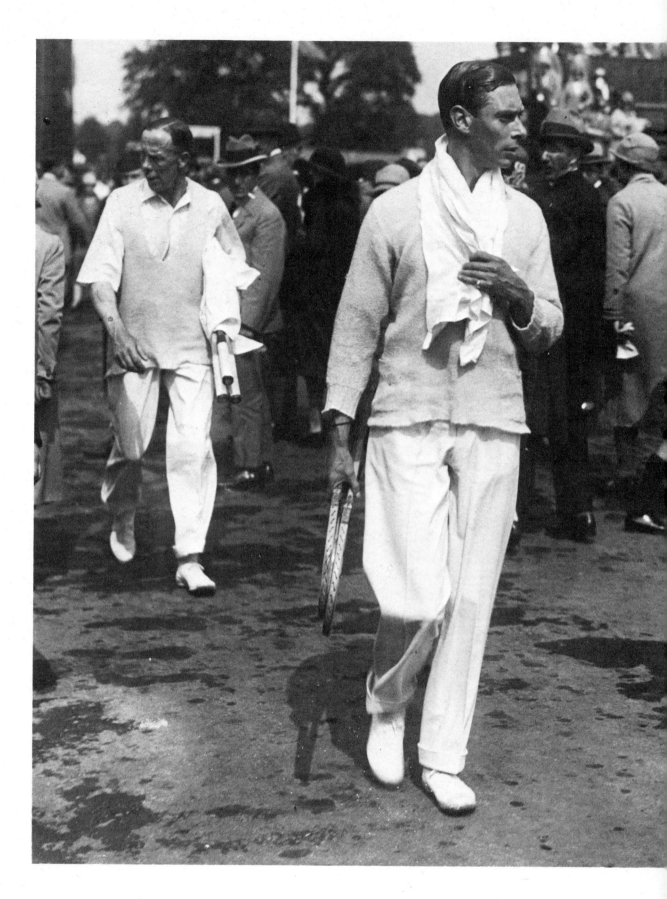

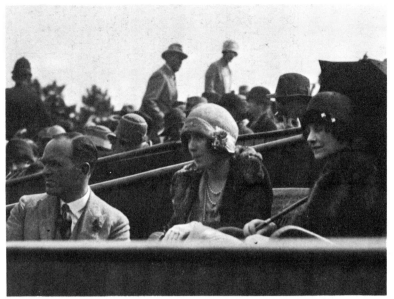

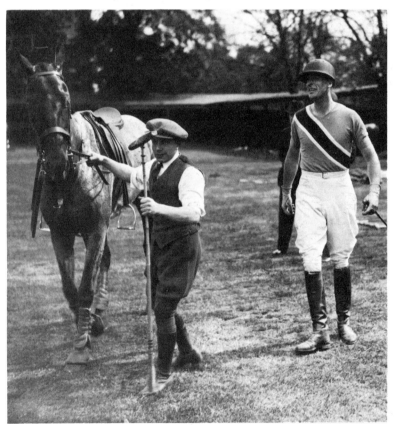

Left
23 June 1926
The Duke of York walks through the Wimbledon crowd on his way to play in the Championships.
Top
The Duchess watches him play.

Above
11 May 1946
Commander Louis Mountbatten about to change horses between chukkas at Hurlingham where he played for the Blue Jackets against the Panthers.

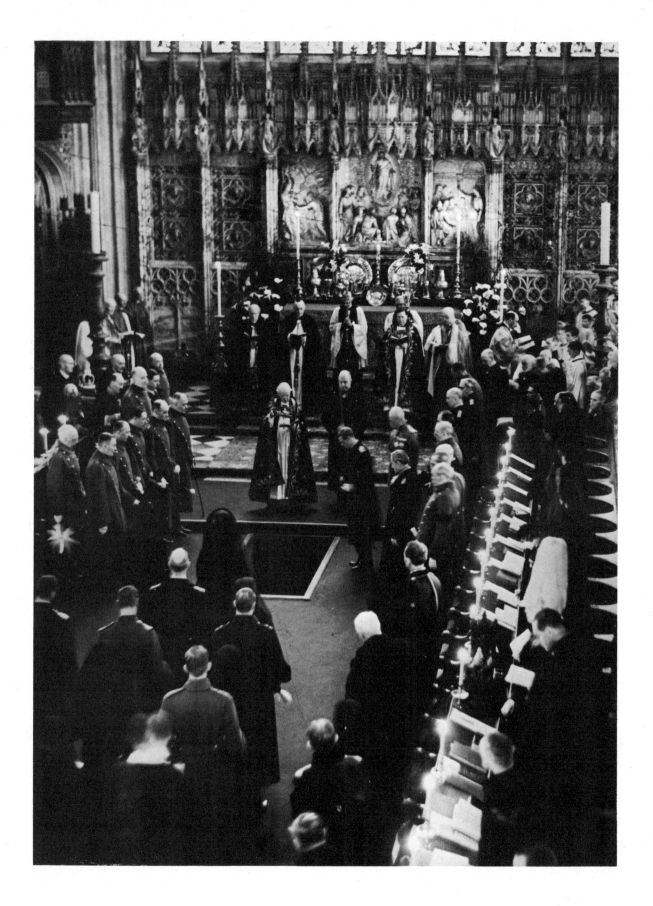

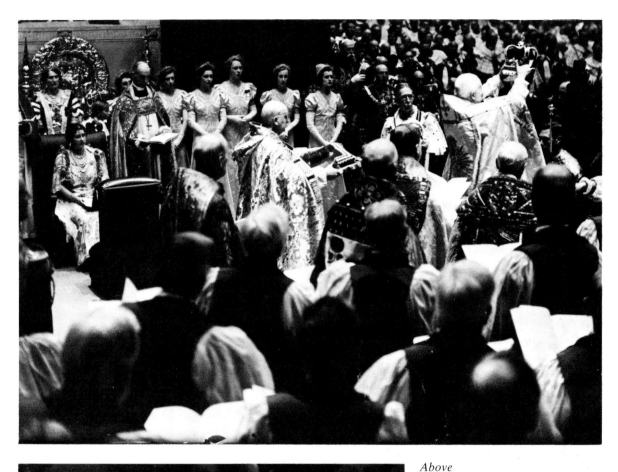

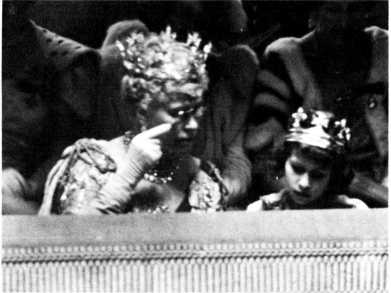

Above
12 May 1937
The supreme moment of the coronation in Westminster Abbey as the Archbishop of Canterbury places the St Edward's Crown (the Crown of England) on the head of the Sovereign King George VI. Queen Elizabeth can be seen seated on the far left.
Left
King George VI's mother, Queen Mary, with his daughter Princess Elizabeth at the ceremony.

Opposite page
28 January 1936
King Edward VIII after scattering earth on the coffin of his father George V, during the funeral service at Westminster Abbey.

(This was a particularly difficult picture to take as the only available light was candlelight which necessitated a very long exposure.)

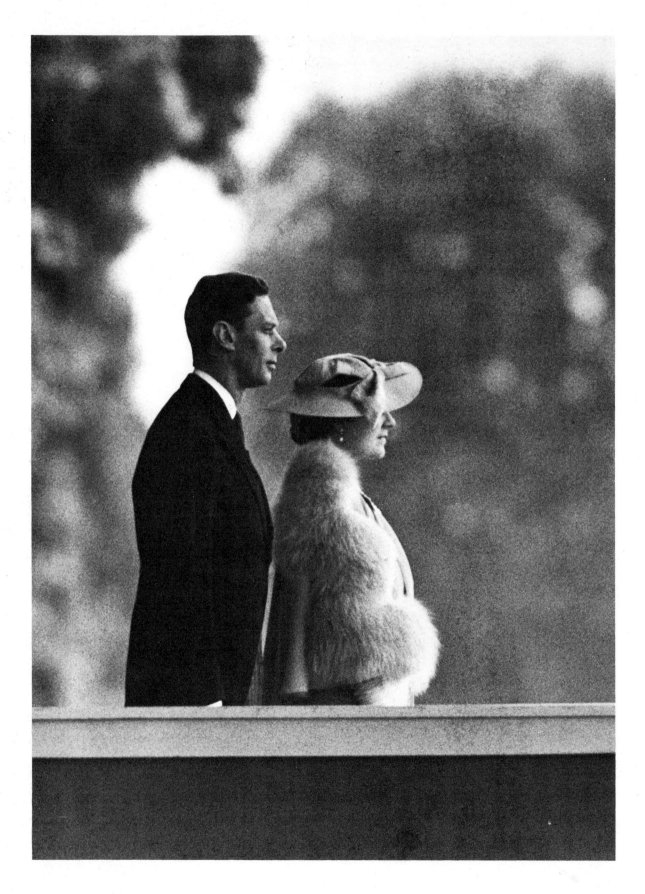

Opposite page
27 June 1937
Their Majesties King George VI and Queen Elizabeth in Hyde Park watching the march past of 90,000 ex-servicemen, one of the biggest parades ever held in this country.

Left
3 July 1936
The Duchess of York (later Queen Elizabeth) this morning visited a display of Scottish goods and cookery at British Industries House, Oxford Street, W1.

Below
5 July 1937
A happy picture showing HM the Queen Elizabeth chatting with Lord Elphinstone during the inspection of the Royal Company of Archers at Holyrood Palace, Edinburgh today. On the right is the King, and in the centre, Princess Margaret Rose and Princess Elizabeth.

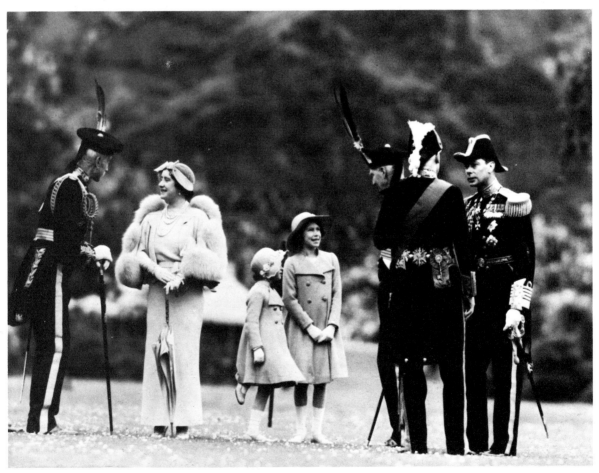

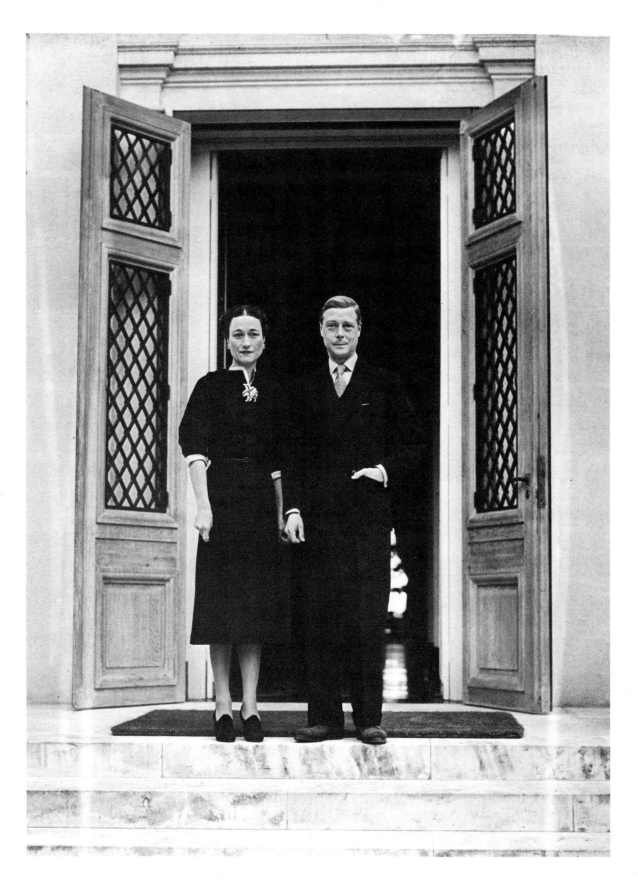

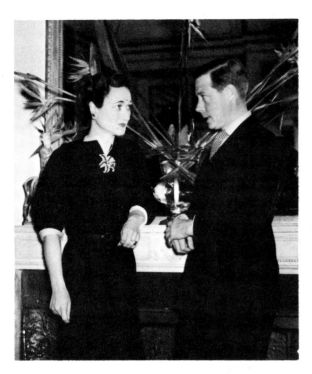

1 January 1939
The Duke and Duchess of Windsor greeted the New Year at their Riviera home in Cap d'Antibes, Cannes. They are the first pictures of the couple since his abdication and show how they spent their New Year's Day quietly together.

Overleaf
6 October 1945
The Duke of Windsor and his mother Queen Mary walking through the autumn leaves in the grounds of Marlborough House. The Duke is staying with her while he is in this country. It is the first time they have seen each other for nine years.

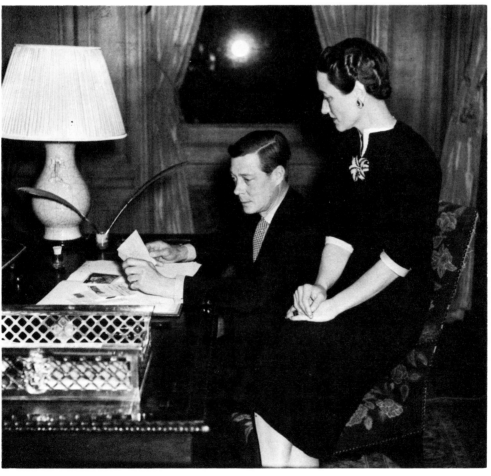

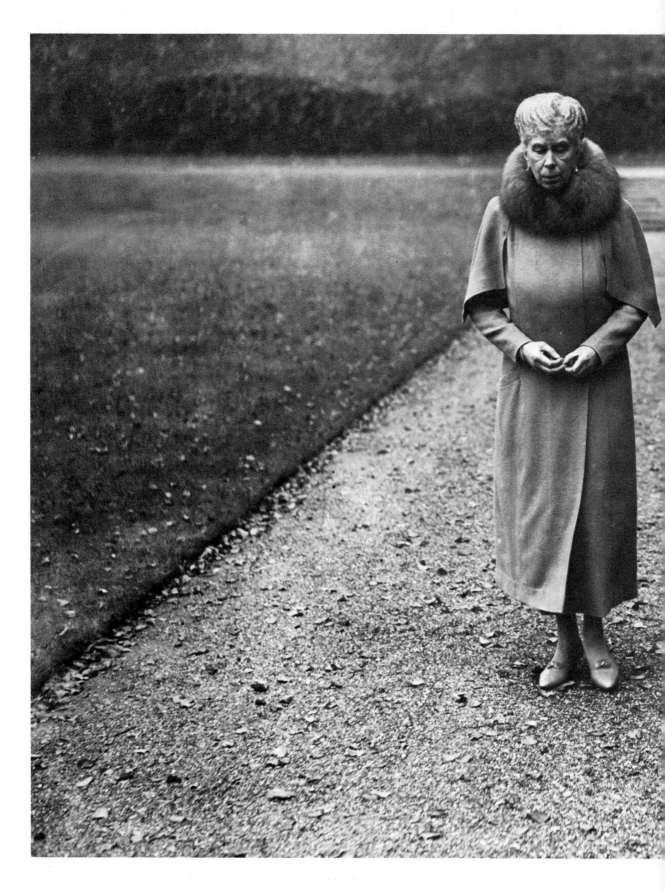

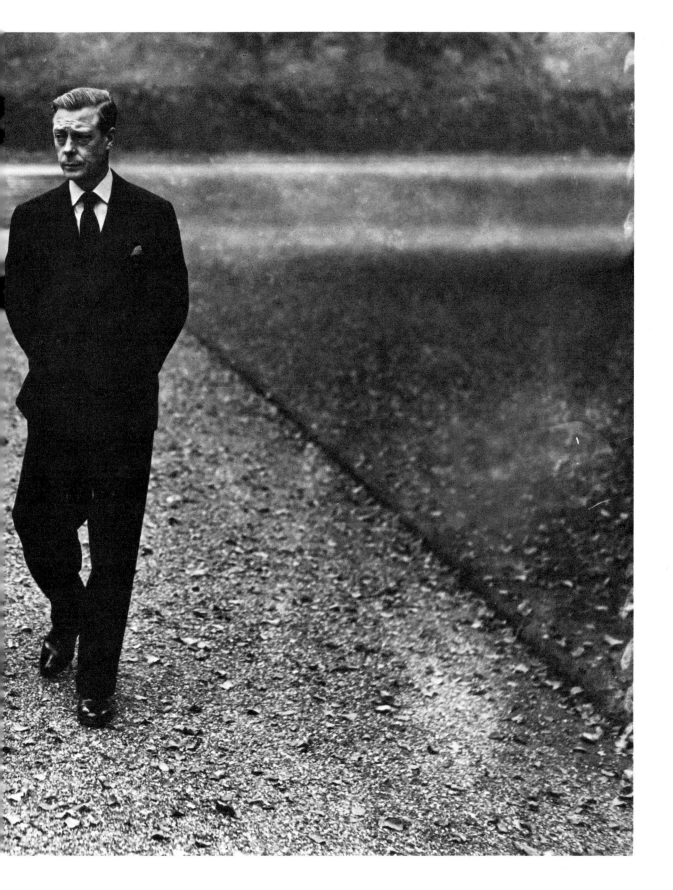

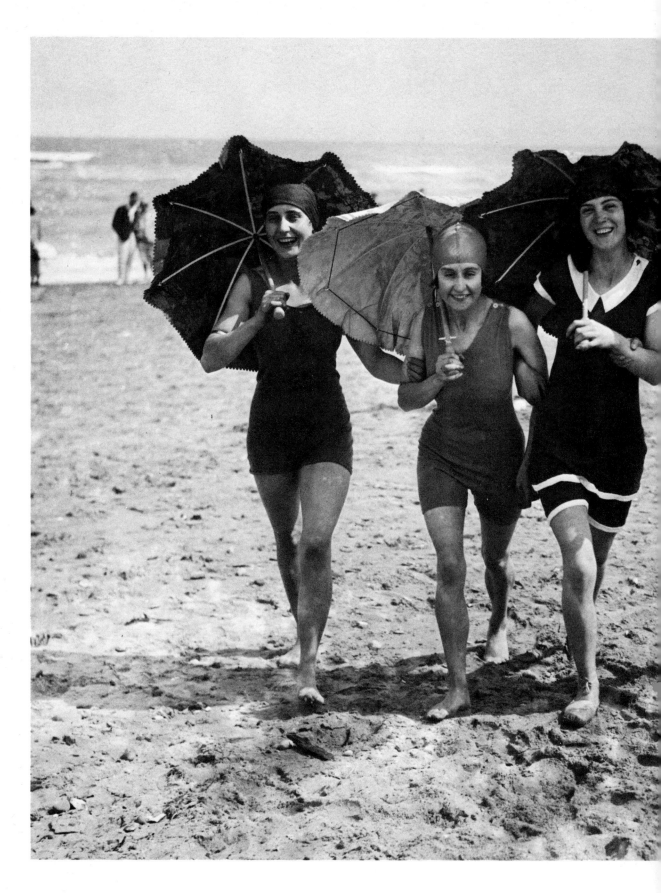

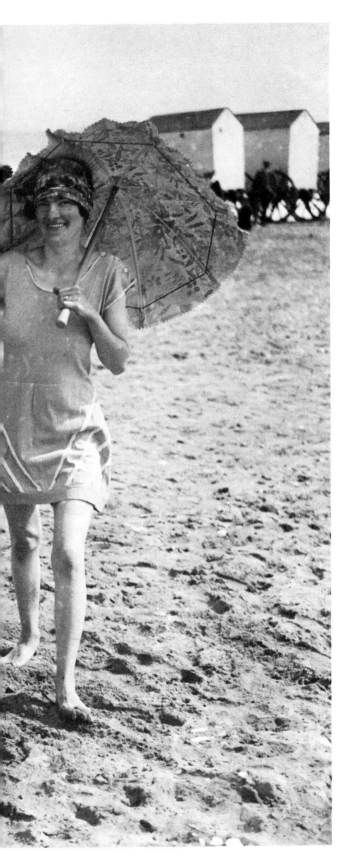

Features

In the mid-twenties Speller managed to persuade newspapers that pictures could do more than illustrate news items. His 'feature' pictures were generally carefully set-up 'stunt' photographs. The most famous is on page 42. Speller had gone to Hyde Park's Serpentine to photograph some routine bathing beauties. He found none, but then he spotted seven small naked boys about to go into the water – and next he saw a policewoman. A sudden idea came: he broke a branch off a tree and, plausible as ever, persuaded all of them to set up this shot, which was published around the world.

Many of Speller's feature pictures were no more than amusing or bizarre; but his photographer's eye sometimes led him beyond these limits, such as the vertiginous view of the steeplejack hanging in front of the clock face and the massive locomotive roaring over the oddly delicate lattice of the Forth Bridge.

1 July 1926
Four bathers on the beach at Skegness, with bathing machines in the background.
(This is a good example of a 'stunt' picture: the women were provided with parasols and specially posed. The 'bathing belle' on the far left was the photographer's wife.)

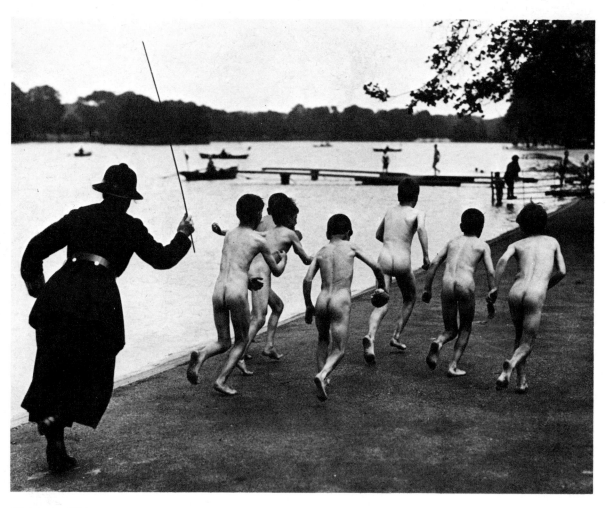

15 August 1926
Speller's most famous feature
picture which was published
worldwide.

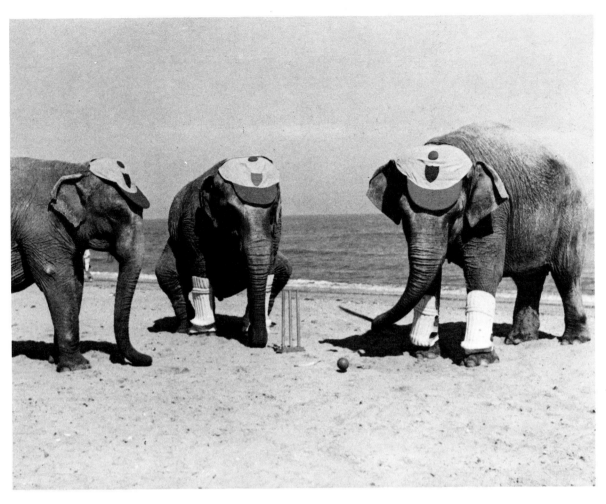

1 September 1936
Holiday makers at Skegness
wondered what had happened when
a number of elephants arrived on
the beach complete with cricket
bats, stumps and pads for a game of
cricket. They were circus elephants
taking advantage of their
appearance locally for a game of
cricket on the sands.

Left
5 February 1934
A ginger cat conducts what looks
like an urgent telephone
conversation.

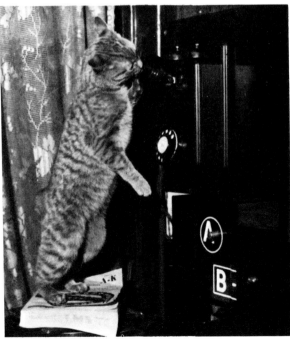

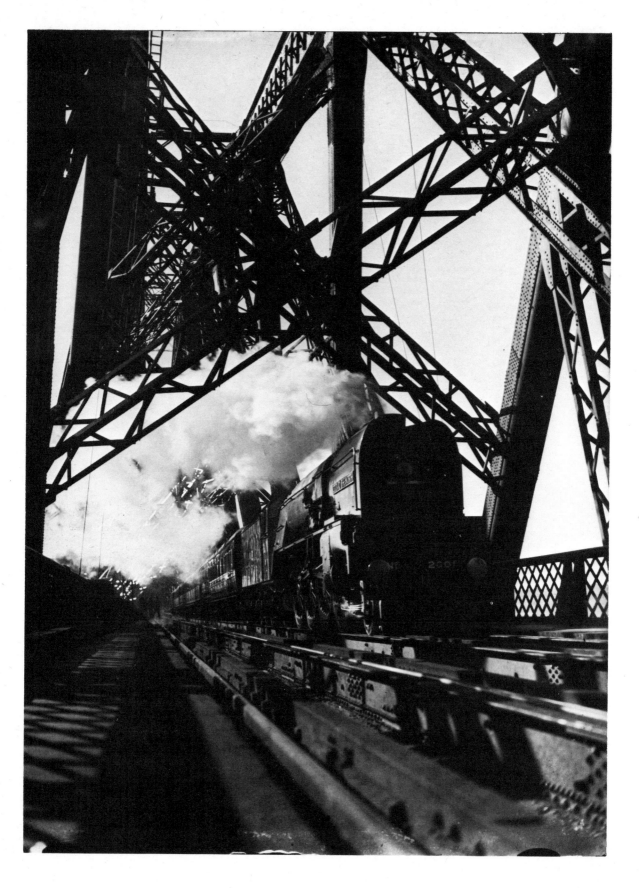

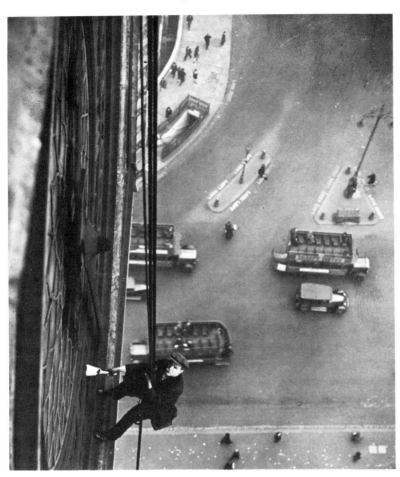

Opposite page
23 September 1935
The Cock of the North crosses the Forth Bridge.

Left
1 April 1937
Mr Larkin the famous steeplejack, at work today cleaning the face of Big Ben.

Below
27 May 1931
This stunt picture 'Land, Sea and Air' was taken on the River Ouse near Huntingdon. Speller made two unsuccessful attempts before getting all three in frame.

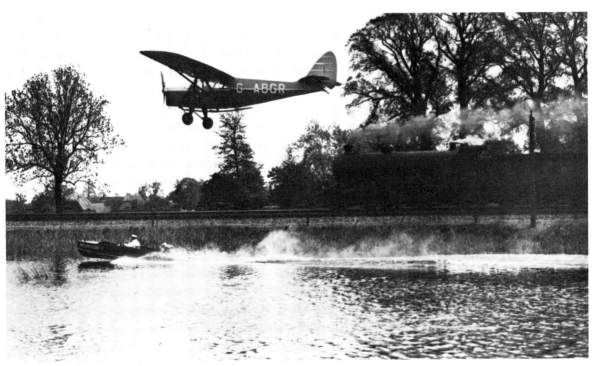

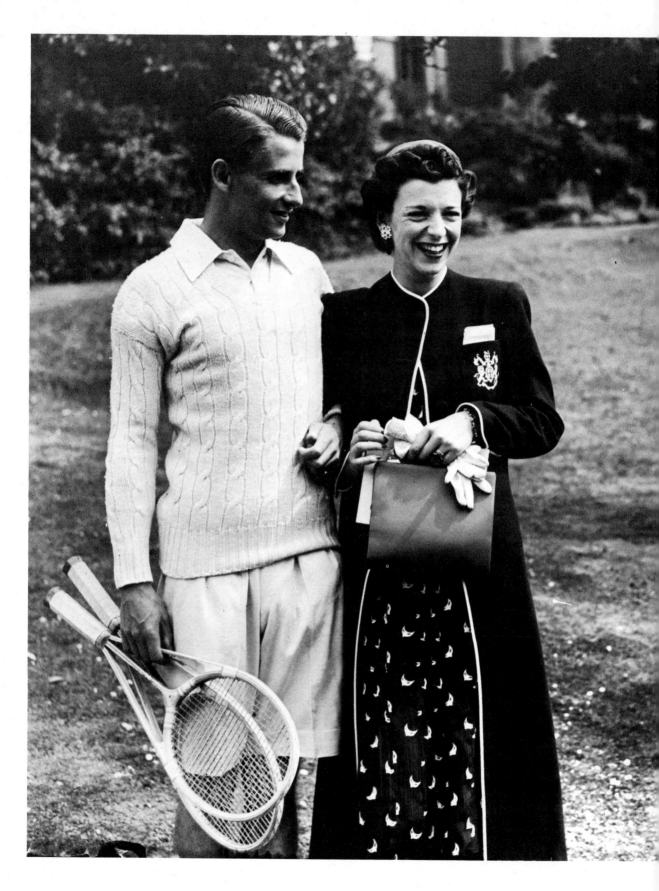

Household Names

Pictures of celebrities of all kinds were in constant demand from the popular press. Speller supplied them, but it was not his favourite work. 'It's not much fun seeing actors arriving in their Sunday best', he says.

But his pictures span an amazing range of personalities, many of whom are still legendary for widely differing reasons: Marlene Dietrich, H. G. Wells, the Aga Khan, Max Miller, J. B. Priestley, Noël Coward, Winston Churchill, Lloyd George....

Even this routine coverage of the famous gave him opportunities for strange and striking shots. The top-hatted Aga Khan, Lord Crewe and his cronies hobnob officiously while, at the end of the reins, the jockey silently eyes them from his mount, part of a different world. Jessie Matthews is carefully retouched by a white-coated technician. Gracie Fields confronts her effigy, as unlike her as such effigies are, even though it is wearing one of her own dresses.

5 July 1937
Many star performers from Wimbledon attended a tennis party given by Sir Arthur and Lady Crossfield at Highgate today. Here Miss Hersey Brooks, daughter of Norman Brooks, takes a picture of Bunny Austin (the Davis Cup player) and his wife.

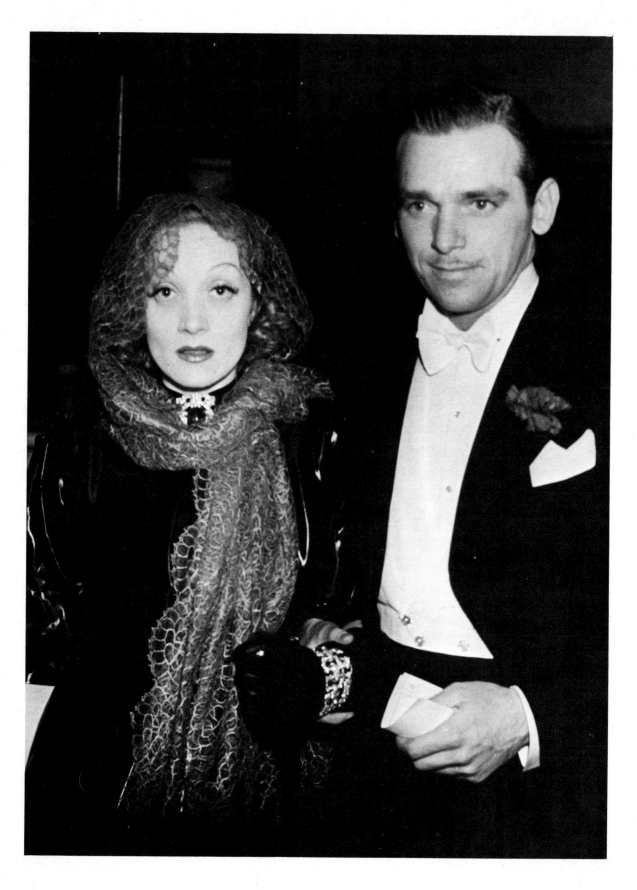

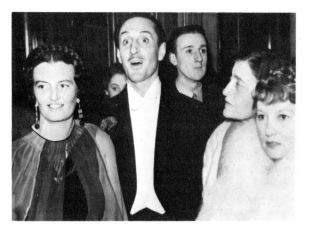

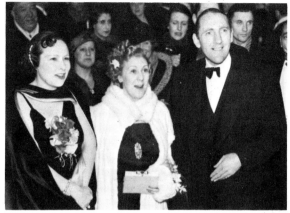

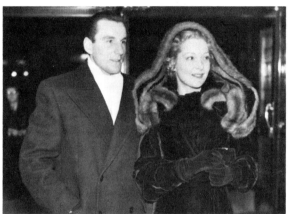

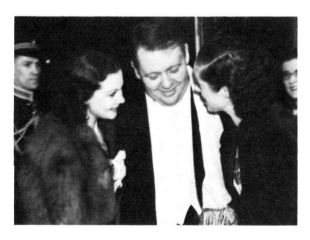

15 October 1936
The première of 'Romeo and Juliet'.
Opposite Marlene Dietrich and
Douglas Fairbanks Jr. *Top left* Basil
Rathbone and Lady Mainwaring.

11 February 1936
The première of 'Modern Times'.
Top right Mrs Bobby Howes, Cicely
Courtneidge and Jack Hulbert.
Centre left Fred Perry and Helen
Vinson. *Centre right* H. G. Wells.

24 February 1938
The première of 'Vessel of Wrath'.
Bottom left Vivien Leigh, Charles
Laughton and Elsa Lanchester.

Bottom right
15 August 1935
Francis Day at the Regal cinema.

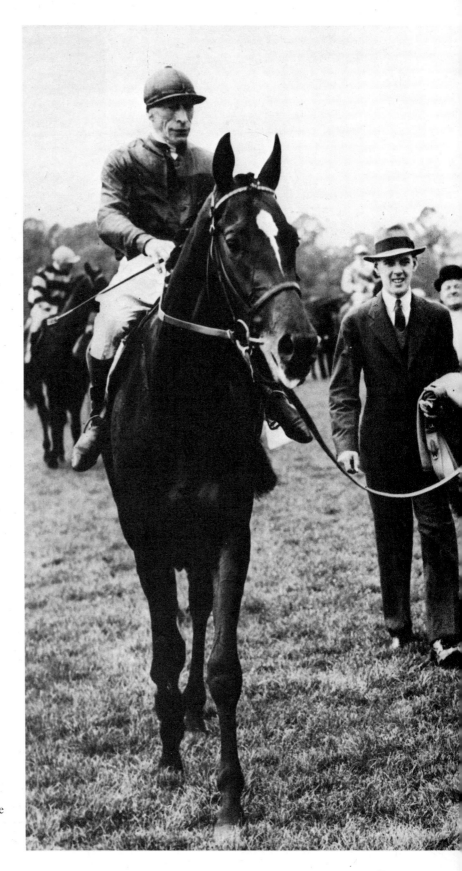

5 June 1935
The Aga Khan shakes hands with
Lord Crewe while leading his horse
'Bahram' into the winner's
enclosure after the Derby. The
jockey is Freddie Fox.

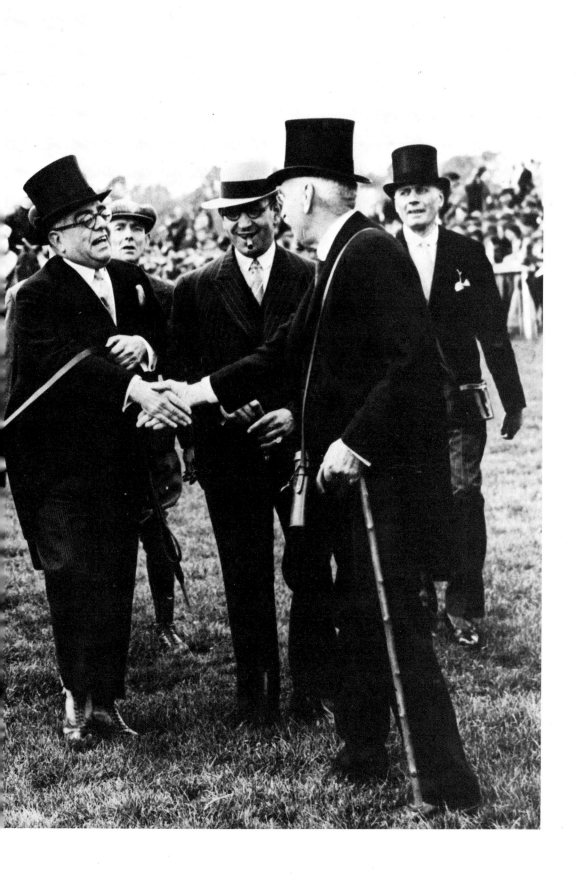

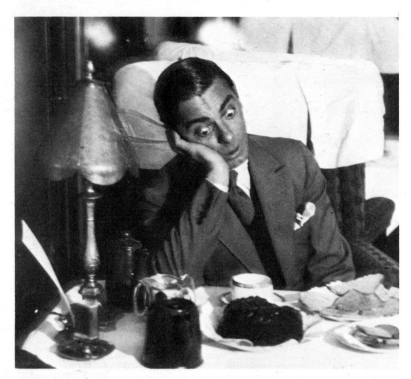

2 January 1935
An exclusive photo of the comedian
Eddie Cantor taken on his first visit
to England on the train from
Folkestone to London.

Below
25 August 1933
Henry Hall, the BBC
dance-orchestra leader, leaving
Waterloo Station en route for
America this evening.

Opposite page
6 July 1932
Jessie Matthews on the set of the
film 'There goes the Bride', having
the final touches of her make-up
applied.

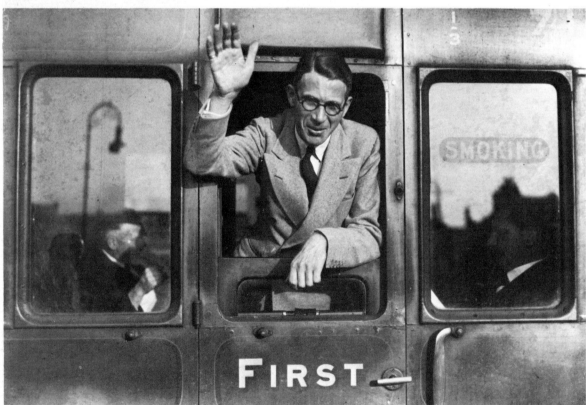

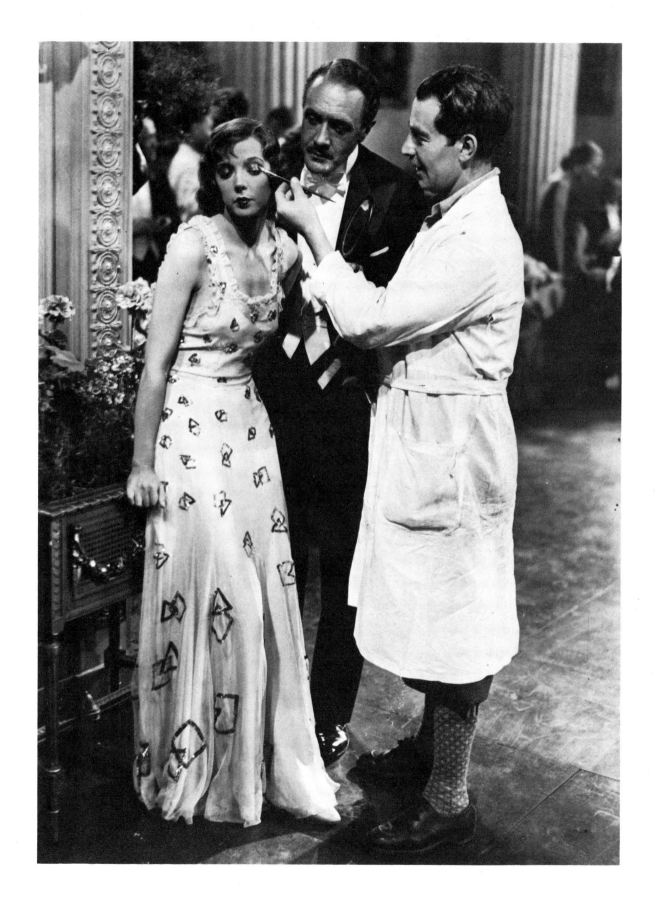

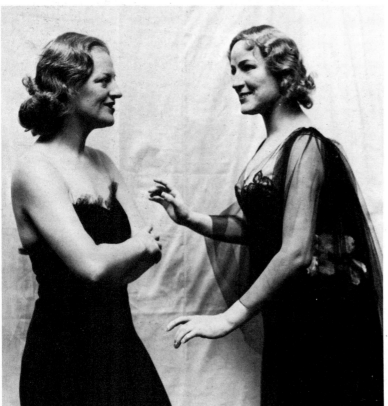

Above
25 August 1939
George Boorman, a Brighton police
constable showing Max Miller his
new song 'Only Myself to Blame'.
PC Boorman who writes songs in his
spare time wrote Max Miller's song
'Why Don't You Make Up Your
Mind?'

Left
11 August 1937
Gracie Fields studies the wax effigy
of herself which is shortly to be
included in the gallery of celebrities
at Madame Tussaud's. Miss Fields
has provided the evening dress.

Opposite page
22 January 1938
Joe Loss with his fiancée Miss
Mildred Rose, who he is to marry
on 27 February.

TO21131

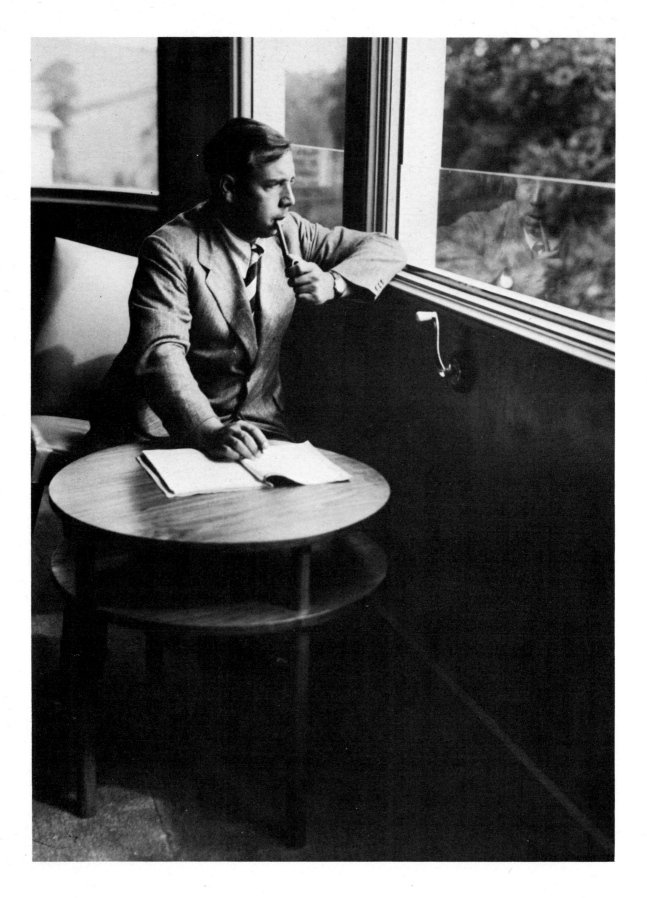

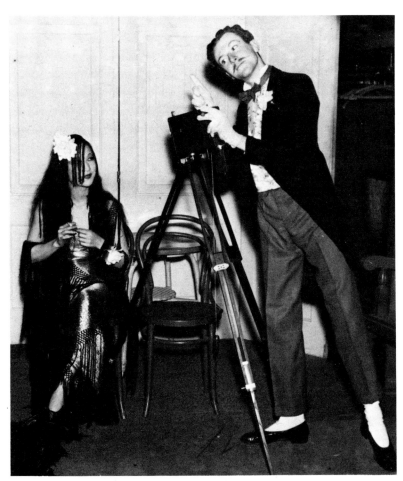

Opposite page
6 September 1933
Mr J. B. Priestley, the famous
novelist, in his study (a very modern
affair) in his Tudor Mansion at
Billingham, Isle of Wight. The
manor is said to be haunted by the
ghost of King Charles I and the
villagers will not go near the house
after dark. Mr Priestley is regarded
as something of a hero for living
there. Mrs Priestley says that she
has heard strange noises but her
husband scoffs at the idea.

11 May 1933
Mr Cecil Beaton photographing
Miss Anna May Wong, the famous
screen star, at the Circus Ball which
was held last night at Grosvenor
House in aid of the London
Homeopathic Hospital. The famous
Grosvenor House ice rink was
turned into a circus ring.

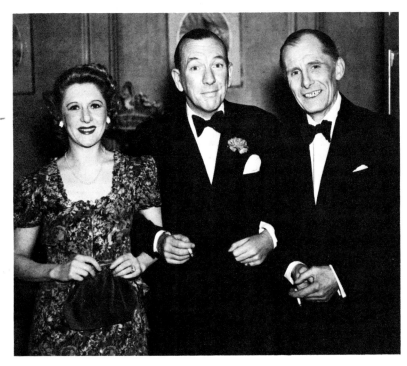

11 March 1946
Mr Noël Coward, with Moya
Nugent and Martin Lewis, last night
after his play 'Blithe Spirit' ended its
run after five years and 1997
performances. Miss Nugent and Mr
Lewis have played in 'Blithe Spirit'
since it was first produced in 1941.

Right
29 July 1943
Wing Commander Guy Penrose Gibson VC, while in London on a short leave, looks in on his old friend Jack Buchanan at the Winter Garden Theatre, after seeing him in the show 'It's Time to Dance'.

Below
26 February 1946
An uninvited audience watching Evelyn Dall and Arthur Askey being filmed in 'The Glamour Girl'.

Opposite page, above
28 August 1941
Richard Greene, still in his uniform of 2nd Lieutenant, with Valerie Hobson, his co-star in the film 'Story Unpublished'.

Opposite page, below
16 March 1946
Michael Redgrave, Deborah Kerr and her husband leaving Croydon for Belfast this morning where they are appearing at a special performance in aid of charity.

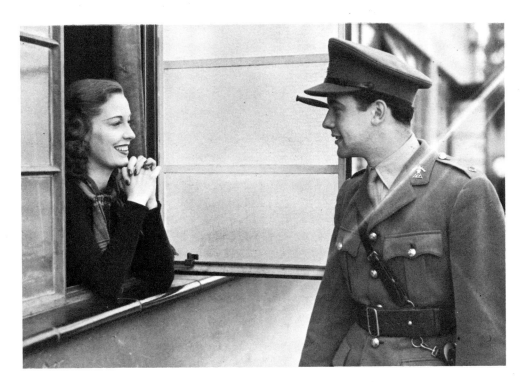

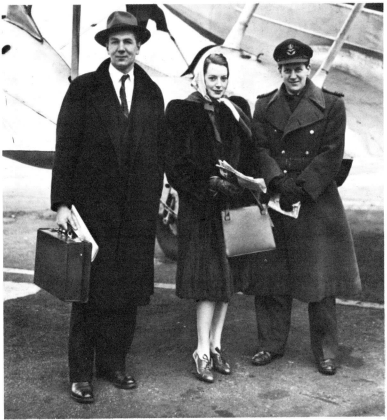

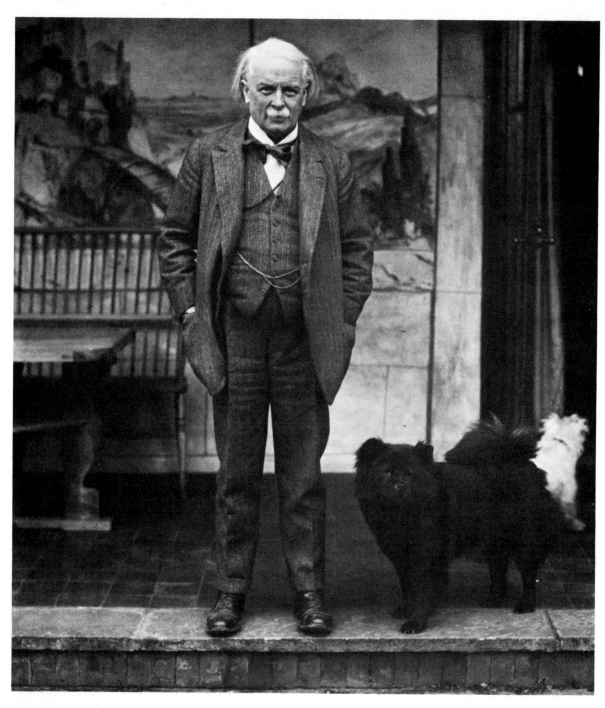

14 March 1926
Mr Lloyd George, leader of the
National Liberals, at his home in
Churt, Surrey.

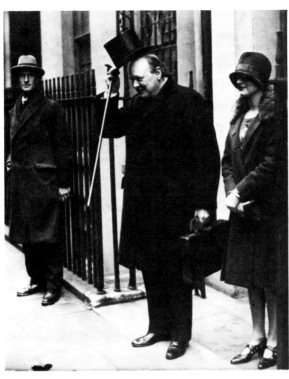

28 April 1926
Mr Winston Churchill, the Chancellor of the Exchequer, leaves Downing Street, and *below* walks to the Houses of Parliament to deliver his Budget Speech. (His private detective can be seen to his right in both photographs.)

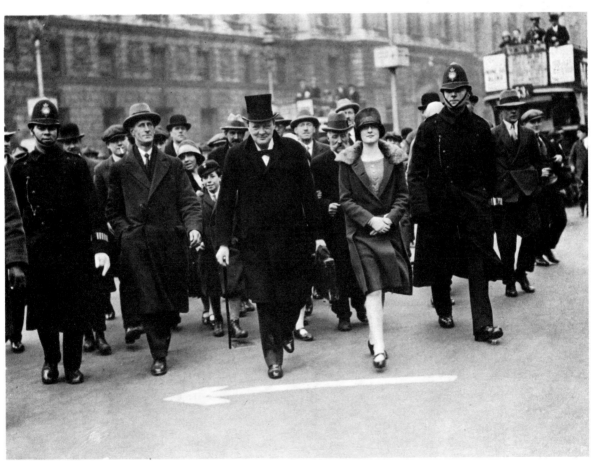

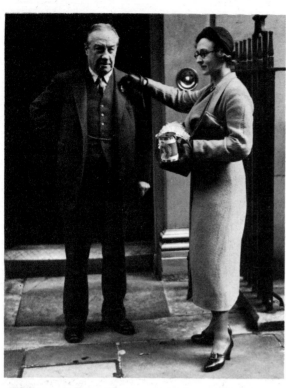

18 June 1935
Mr Stanley Baldwin, the Prime Minister, having just bought his Alexandra rose.

Below
15 August 1928
Mr Stanley Baldwin being filmed for a newsreel at Downing Street.

Opposite page
3 September 1939
Mr Neville Chamberlain, the Prime Minister, outside 10 Downing Street, the day war was declared. Behind him stands his Parliamentary private secretary, who later became Prime Minister – Sir Alec Douglas-Home.

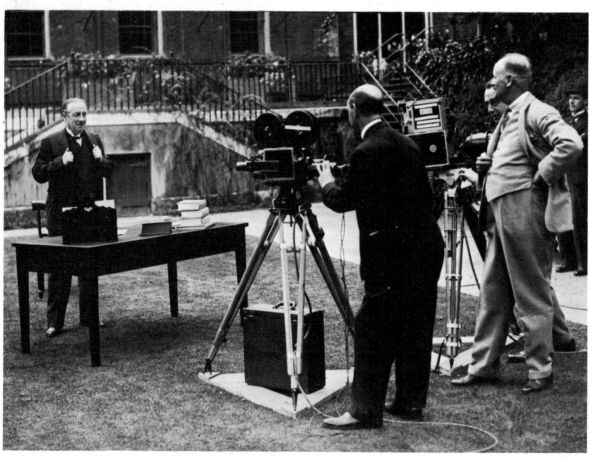

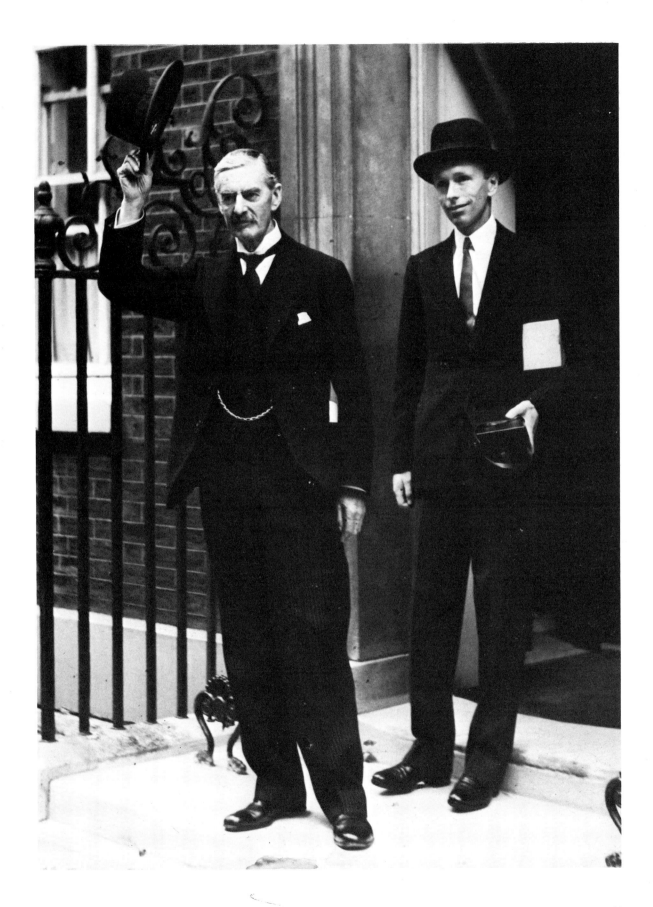

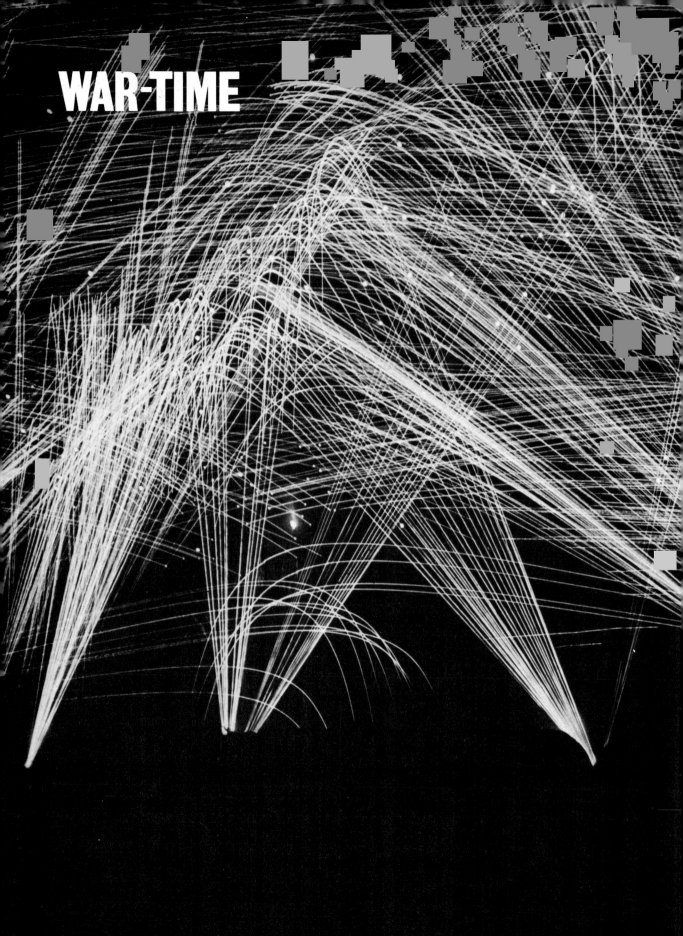

WAR-TIME

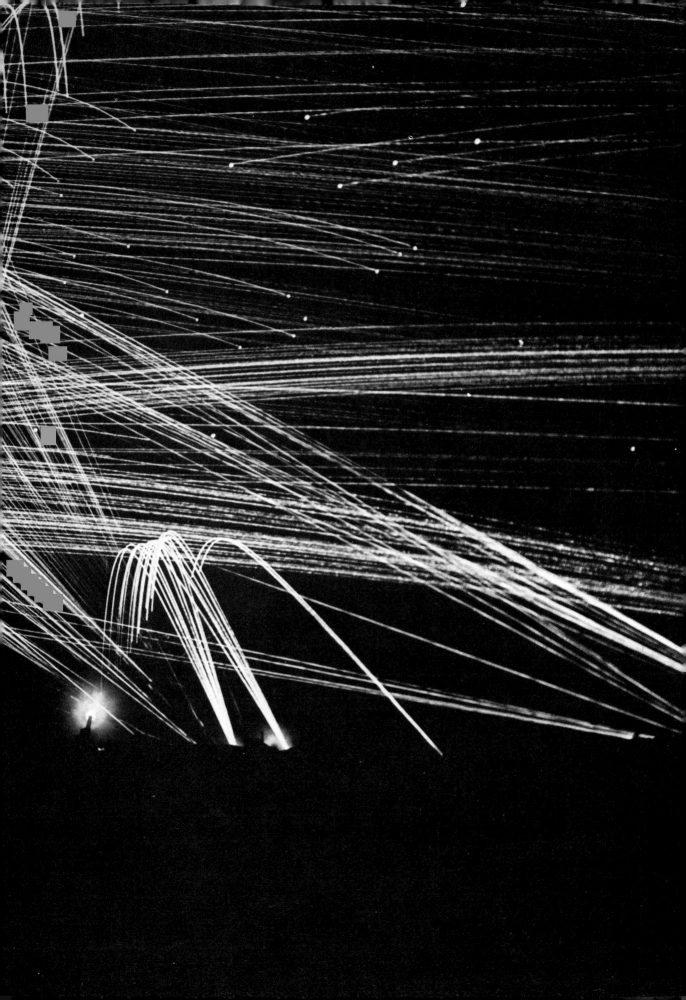

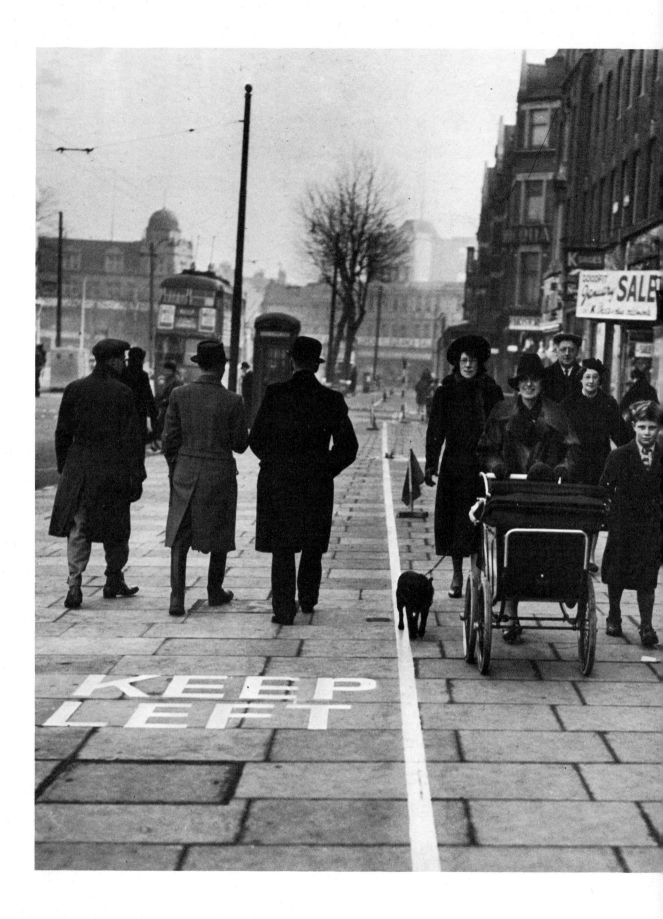

Life Goes On

After the fall of Poland in 1939 Britain expected the bombers to arrive at any moment. Cities were blacked out and gas masks issued. Everyone from schoolboys to shop assistants was drilled in their use. One picture here shows a special all-enveloping mask for a baby. Three million people – hospital patients, mothers and children – were evacuated from the cities to the countryside. Speller recorded the confused and often absurd spectacle of people preparing to meet the threat, coping good-humouredly with the government's well-meant but often futile schemes, such as white lines painted on city pavements to stop people from bumping into one another during the black-out. The chaotic scenes at railway stations gave him just the kind of 'human interest' pictures he excelled at. He caught the gaiety of evacuee children making the most of their enforced outings. He was also keenly aware of the grotesqueness of gas masks worn by chambermaids making a hotel bed. The file of masked schoolboys descending the ultra-modern glass-walled staircase reminds one of his earlier, specially-posed 'stunt' pictures.

But the threat of invasion did not materialize for almost a year. As we know now, this was the time of the 'phoney war'. When the Blitz did begin, in September 1940, many evacuees had already returned and had to be sent away again.

29 January 1940
'White Lines' for pedestrians are the latest war-time experiment. On one of the main thoroughfares of Ealing the pavement is divided into three sections for the pedestrian traffic – one nearest to the shops for 'shoppers' only. The idea is to save them from bumping into each other in the black-out, so it is hoped that the shuffling of innumerable feet will not rub out the lines too quickly and so make them invisible.

Previous page
31 July 1944
The guns are seen blazing from remote fields of southern England where anti-aircraft crews are shooting down a bigger percentage of flying bombs each day.

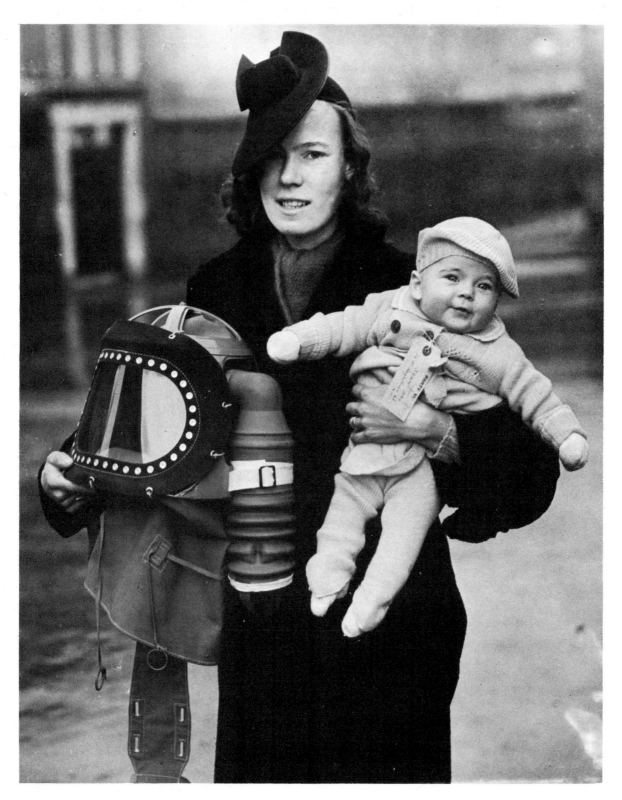

2 November 1940
A mother carries her baby and her
baby's gas-mask as they leave North
London for evacuation.

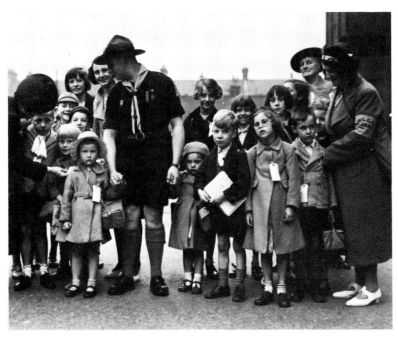

Left
13 June 1940
This boy scout assisted in seeing the little Londoners to their trains. Some 20,000 toddlers are leaving their different schools today for safe areas.

Below left
22 May 1941
These two little kiddies were very tearful as they left for safer areas.

Below right
26 February 1940
Foster mothers in Bedford kiss their little guests goodbye as they leave for their new homes at a government camp in Henley. The children (200 in all) were evacuated to Bedford some time ago from the Alexandra Orphanage, Reigate.

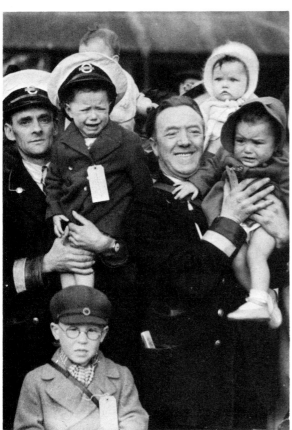

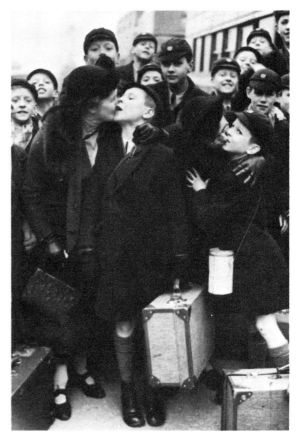

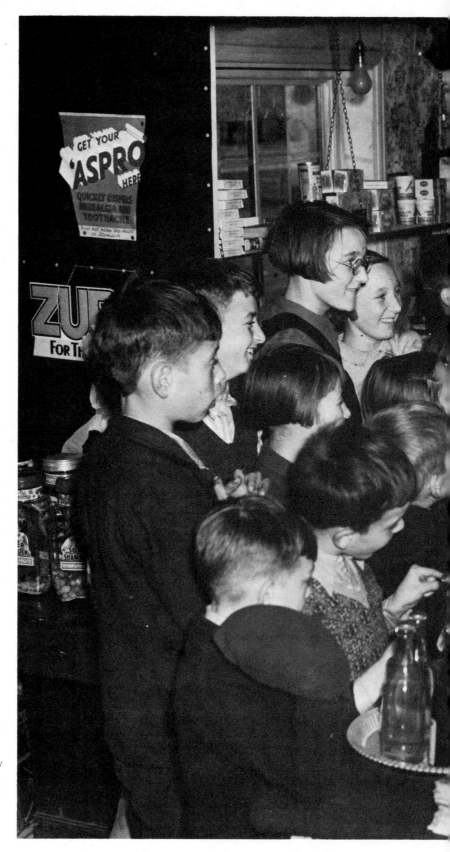

14 October 1940
These young evacuees are now
becoming acquainted with their new
surroundings and soon found the
sweet shop in this Berkshire village.
They are among hundreds of young
children who have left the London
area since the intensive bombing
began.

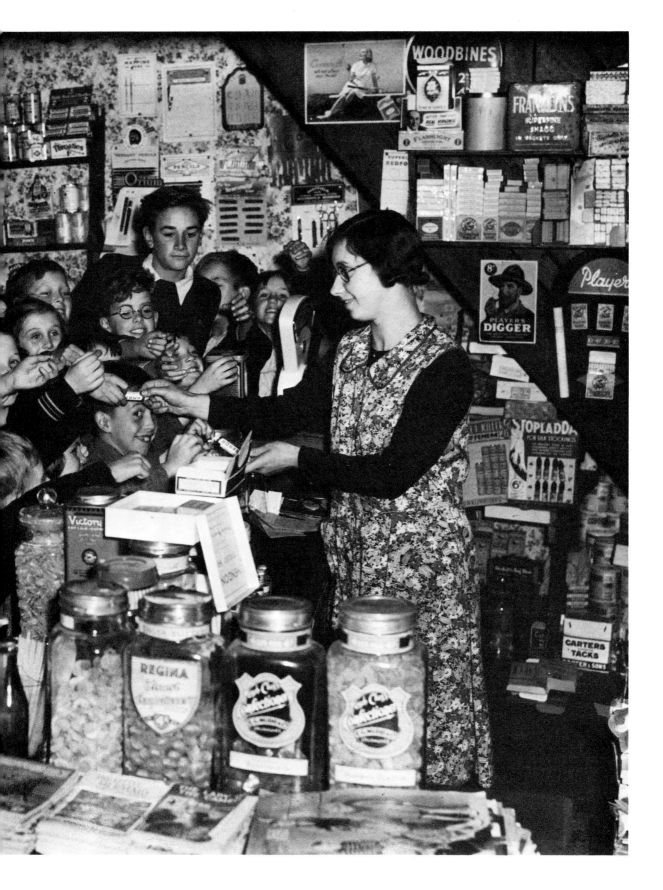

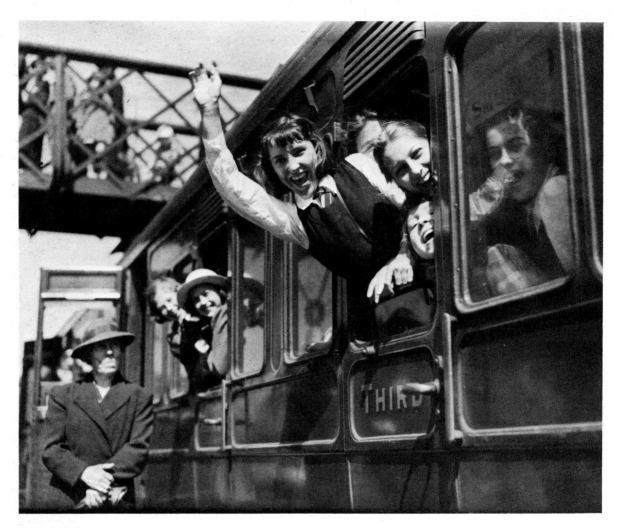

19 May 1940
A happy party of school-children
wave goodbye as their train leaves
for Wales. They are among 10,000
evacuees who are being transferred
by special train from London and
the Medway towns, to new billets in
Monmouth and Glamorgan.

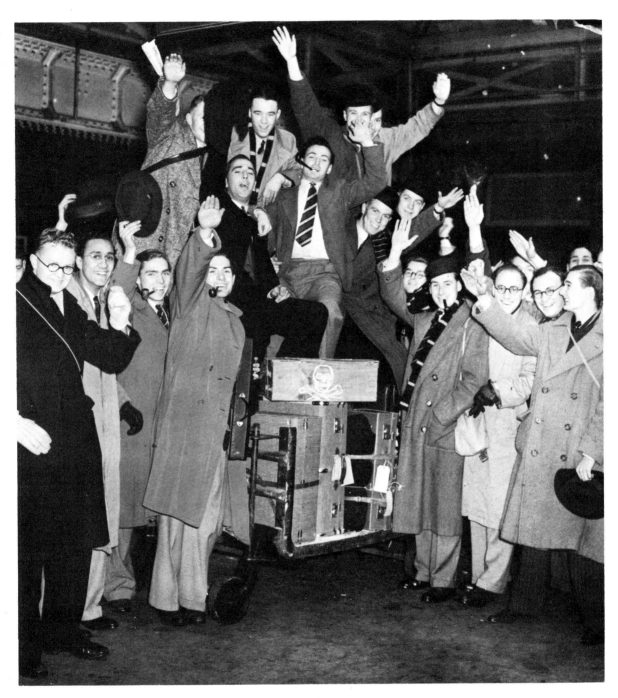

28 October 1939
Students of Guy's Medical School
with their luggage before departing
on a specially chartered train for
their country quarters.

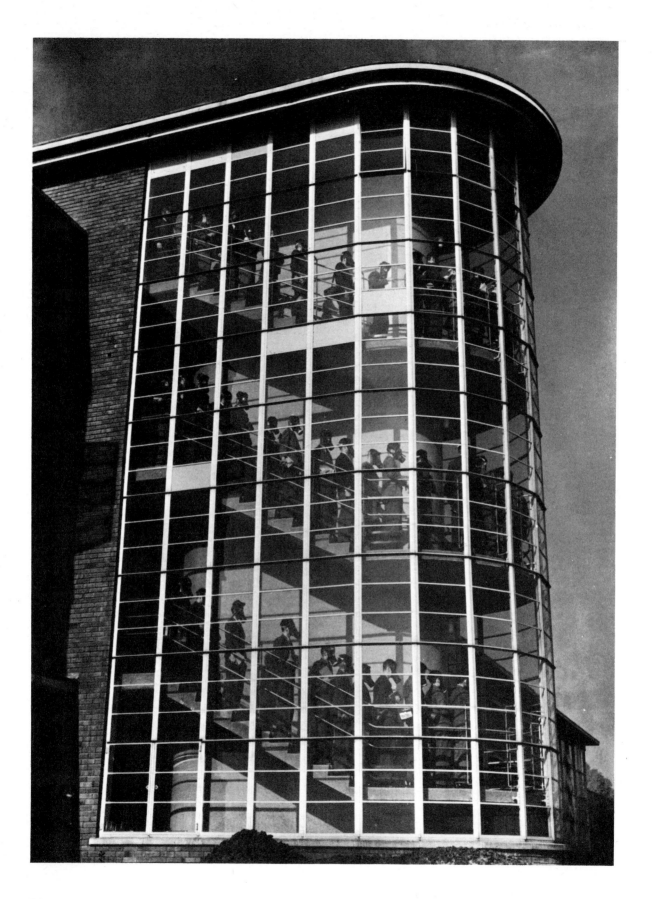

74

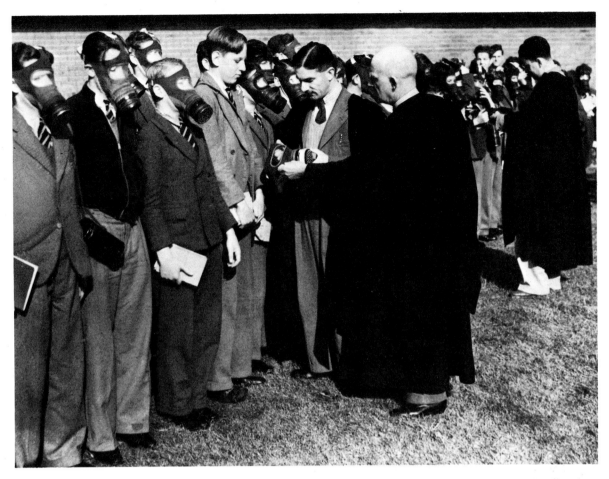

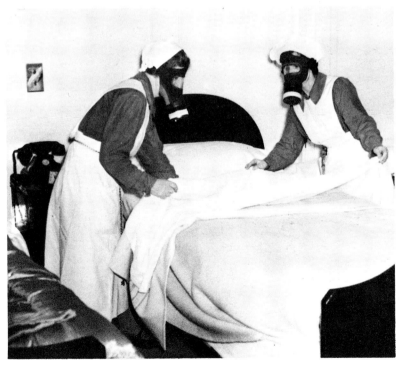

Opposite page
8 October 1941
The boys of Chislehurst and Sidcup County School present a rather 'Wellsian' picture as they file down the glass-walled staircase in their gas-masks.
Above
Gas-mask drill is now part of their school curriculum.

13 June 1941
All the 800 members of the Grosvenor House Hotel staff wear their gas-masks for 20 minutes each week in a regular practice to accustom them to carrying on their normal duties in their respirators.

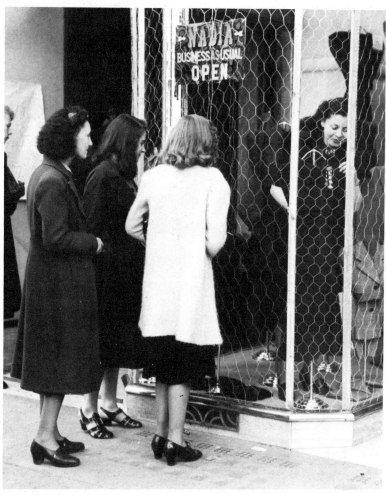

23 September 1940
Many of the bombed shops in
Oxford Street are now nearly ready
for reopening. Here shoppers view
the articles for sale through wire
netting which has been erected
owing to the windows being broken.

31 March 1941
All the employees at a well-known
Bayswater store have to wear their
gas-masks for half-an-hour every
morning as practice. Customers are
asked if they will also put their
gas-masks on during this period.

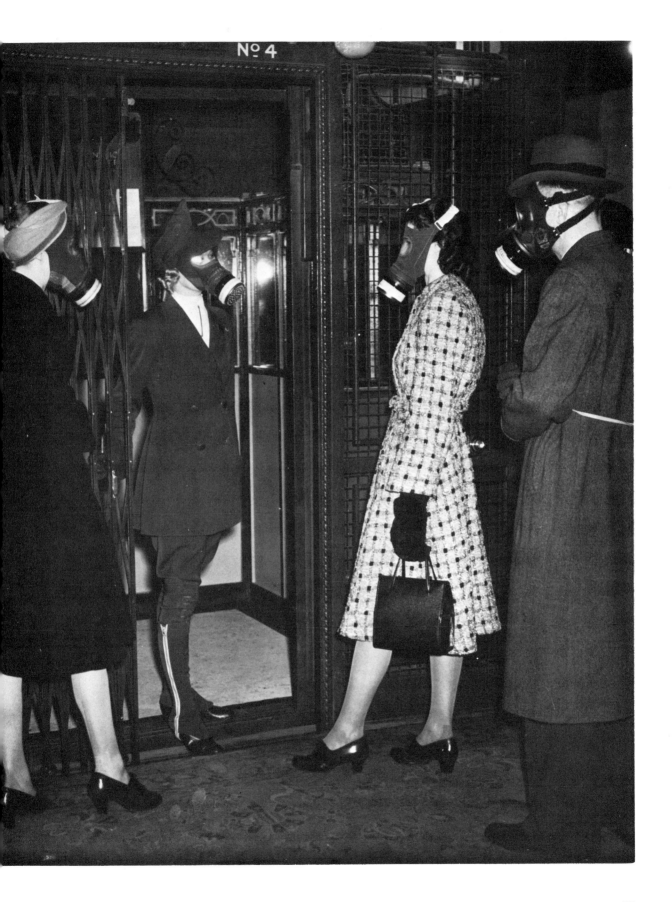

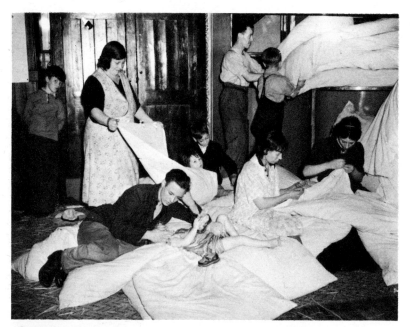

Left
21 September 1940
Preparing beds at a hotel in Windsor for people rendered homeless by the attacks of the Nazis.

Below
18 September 1940
Parents and children who have been made homeless following the ruthless bombing by the Nazis in the SE district of London, are now being cared for at a voluntary centre.

Opposite page
12 September 1942
Miss Kitty Fagg accompanies her sister, Mrs Oakham, when she entertains her colleagues with a song at lunchtime. In the background is one of the many cautionary posters by Fougasse, the well-known war-time cartoonist.

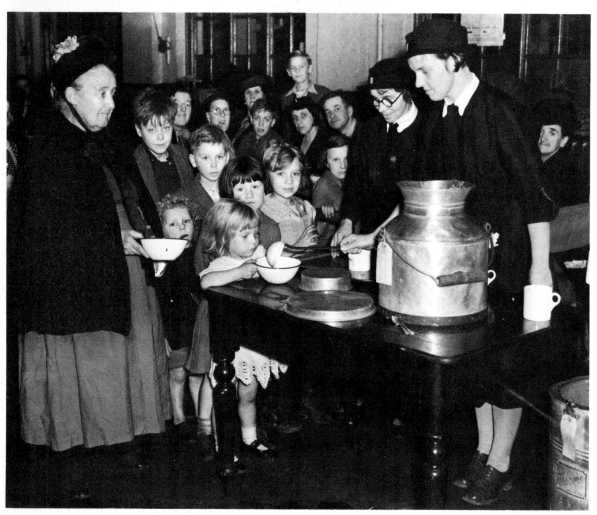

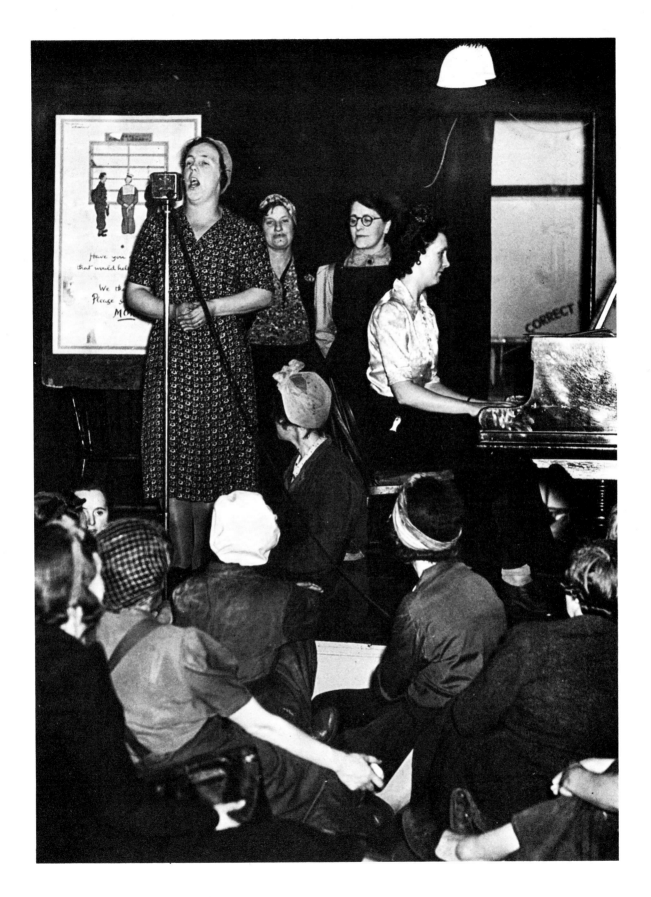

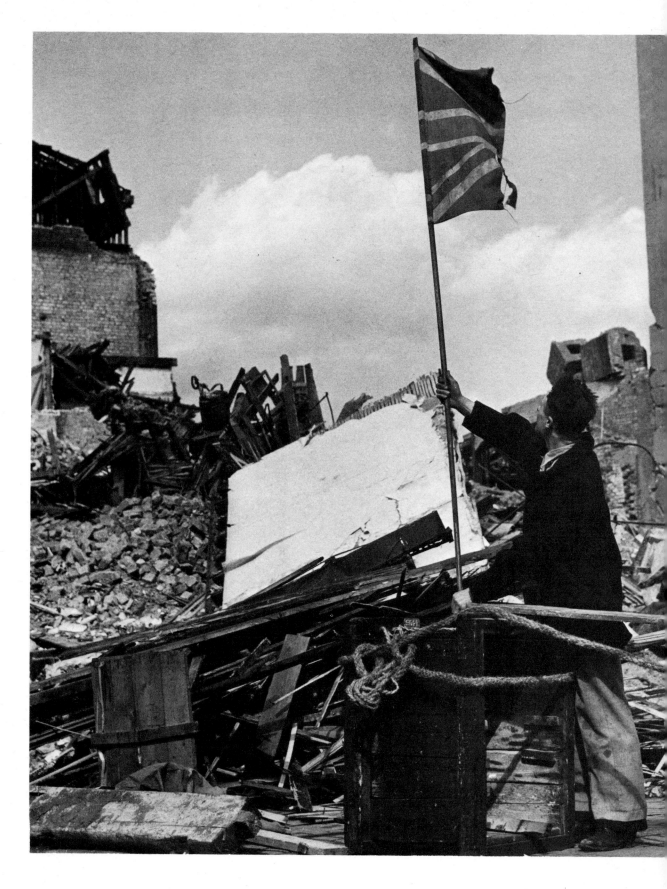

Bombed

Most of the pictures in this chapter were taken in the autumn of 1940 at the height of the Blitz, when London was bombed almost every night for months. Londoners retreated to the steel Anderson shelters dug into their gardens, or spent the night in tube stations. Even so, forty thousand people were killed at this time.

Speller's many photographs of the damage and the homeless are graphic and moving, but lack the horror of many war pictures we are now used to, mainly because all news photographs had to be passed by the censors at the Ministry of Information before publication. The cheerfulness of the bombed-out families, which is so evident from these pictures, was quite unfeigned, as anyone who lived through the Blitz will know. Speller was particularly struck by the helpfulness of all those he photographed.

A quirky variant of the usual propaganda shot is provided by the bombed building with *half* a Union Jack flying over it. The full extent of the devastation is made clear; but even more telling is the vicar tenderly bending over his felled statue of Milton.

20 September 1940
Over the ruins of a bombed habitation a Union Jack was hoisted to show the spirit which still prevails in Britain, in spite of Hitler's efforts to create panic. During a following raid, bombs were dropped in the same vicinity, splitting the flag in half, but the other half continued to flutter valiantly.

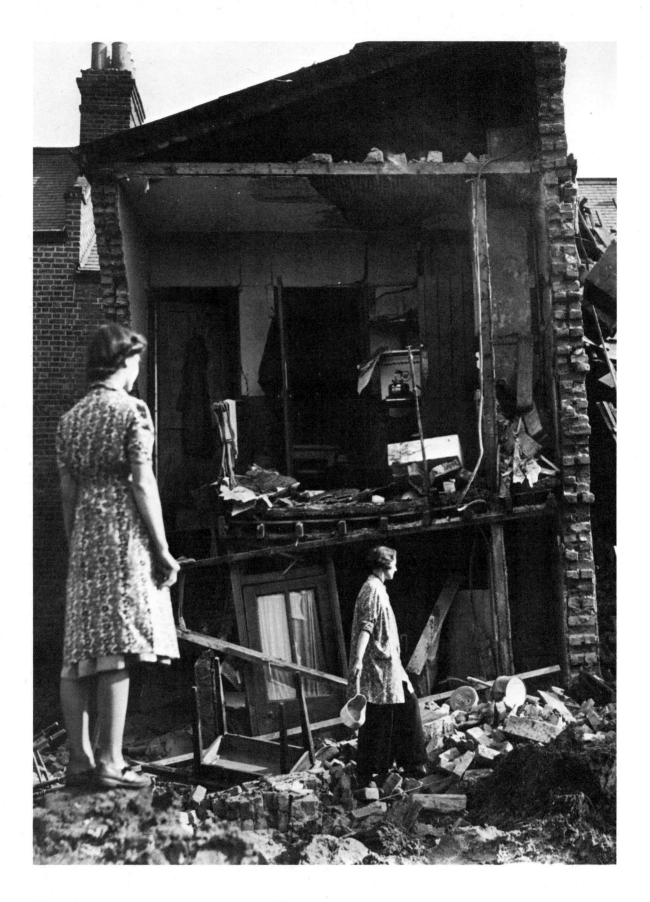

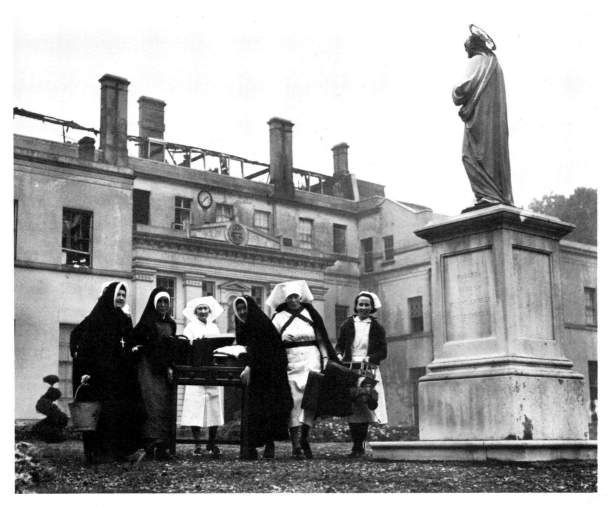

26 September 1940
Nuns retrieving furniture from their
SW London convent, which was
severely damaged when German
aircraft again raided London.

7 September 1940
Occupants surveying the damage
done to their house by last night's
evening raid over London. The
kettle is still on the gas stove.

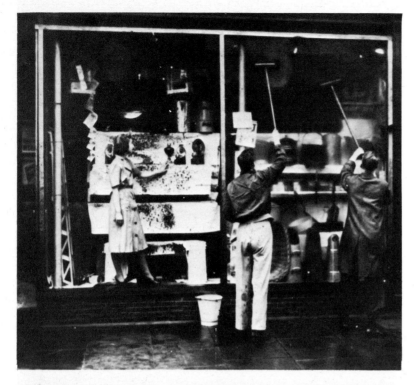

30 September 1940
Shop assistants clean their windows after an oil bomb fell close by last night. The bomb caused a crater but, apart from splashing oil, caused no other damage.

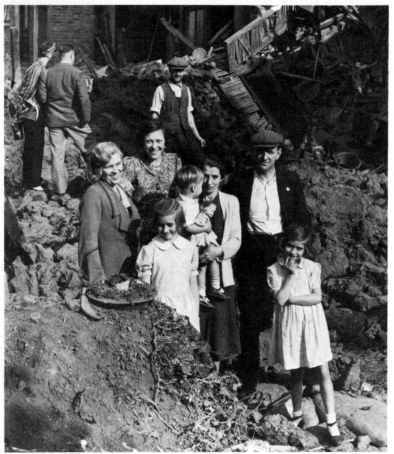

Left
15 September 1940
An entire family of seven escaped injury, when their house received a direct hit from a bomb. They were fortunately in their shelter which can be seen in the foreground undamaged.

Opposite page
21 September 1940
One of the families in the shelter in which they would have had a terrible experience had it not been for the presence of mind of the local warden. Following an explosion believed to be caused by the dropping of a land mine in the SE district of London, he found a delayed-action bomb about seven yards from the crater, which was in a tennis court. He promptly cleared the residents from the nearby houses and shelters. Some time later another explosion shook the neighbourhood and when the people returned to the scene of the damage they realised what a narrow escape they had had.

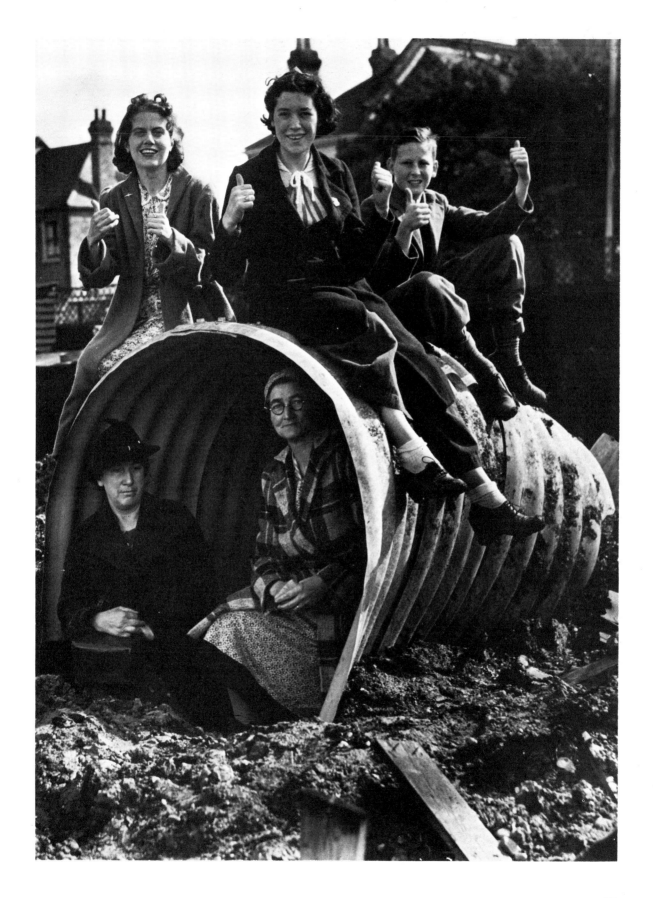

85

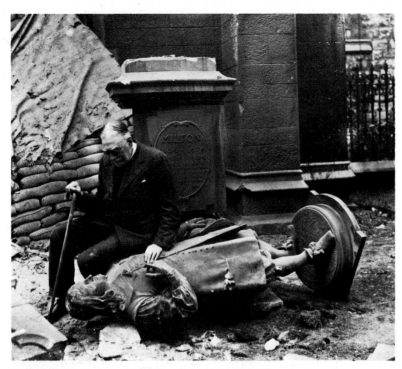

Left
25 August 1940
The vicar of St Giles' Church, Cripplegate, looking at the famous statue of Milton which was felled last night during the bombing raids.

Below
10 June 1941
Bernard Hailstone, who in civilian life was a well-known artist, is now a member of the Auxiliary Fire Service, and spends most of his spare time in painting blitzed buildings in London. This painting of the ruins of St Andrew's Church, St Bride's Street, London will help to form a new exhibition of AFS paintings in London.

Opposite page
12 January 1941
The curate of a recently-bombed London church, near Battersea power station, reading the lesson during today's service.

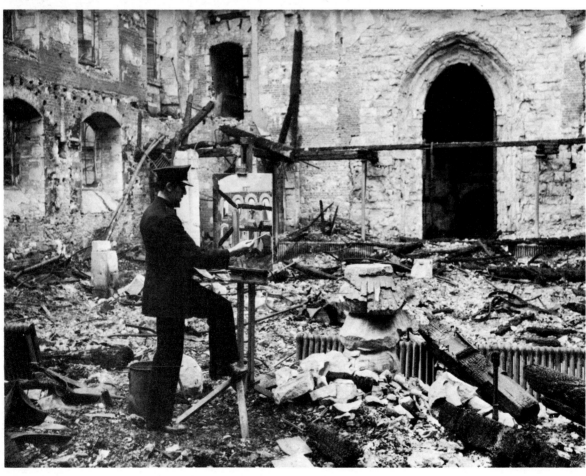

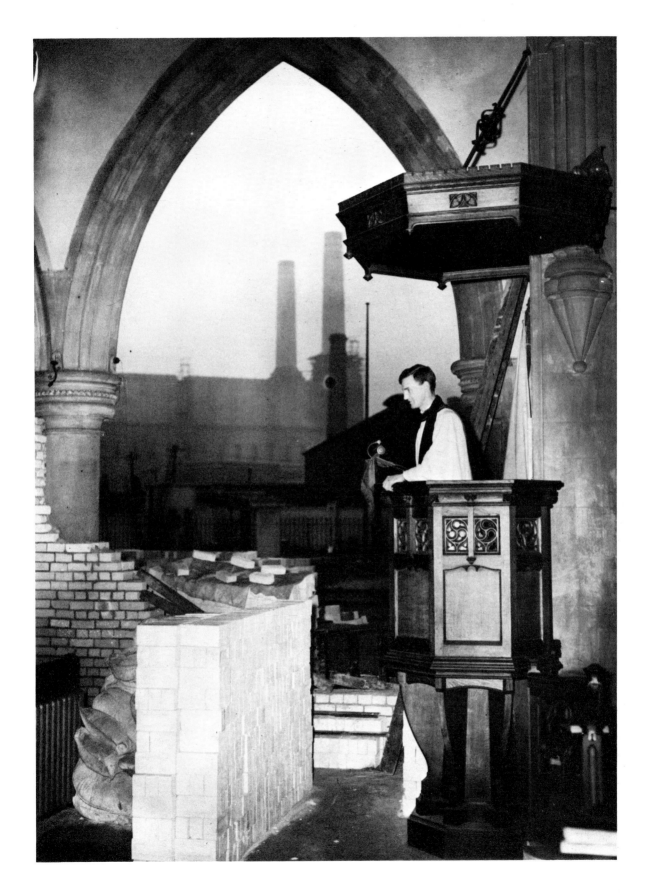

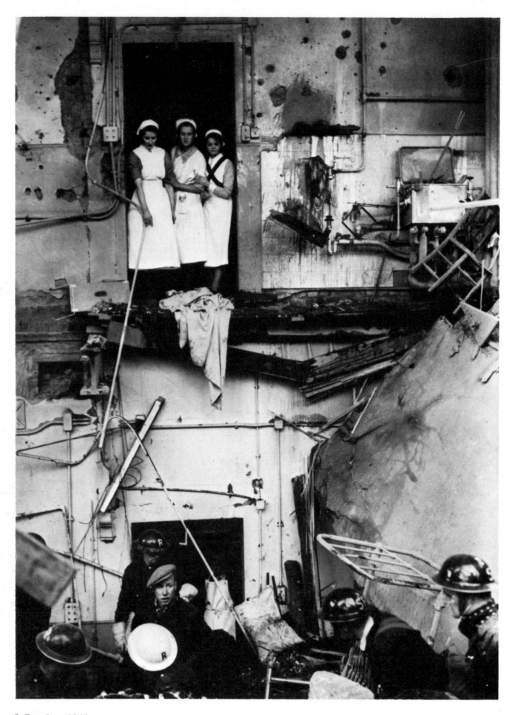

9 October 1940
Nurses viewing part of St Matthew's
Hospital, Hoxton, one of many
non-military targets hit during last
night's bombing.

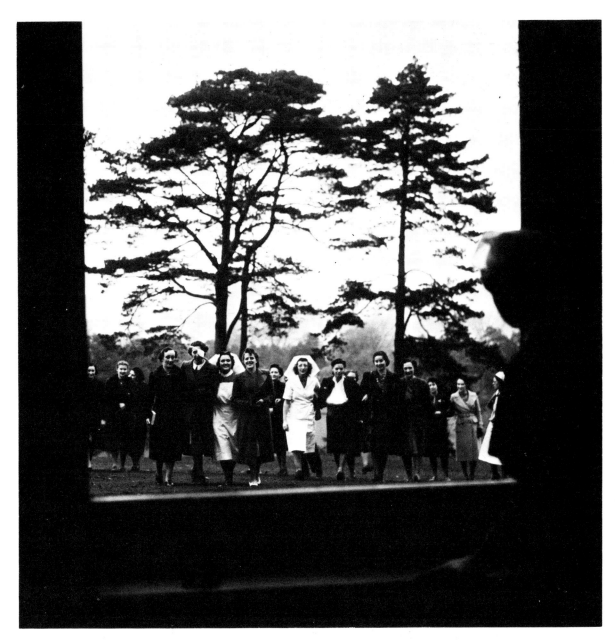

6 November 1940
A view through a window showing
nurses enjoying a stroll in front of a
well-known estate 'somewhere in
Surrey' which is now a rest home for
nurses. Some of them have suffered
minor injuries after working in
many famous hospitals in the
present abnormal circumstances.

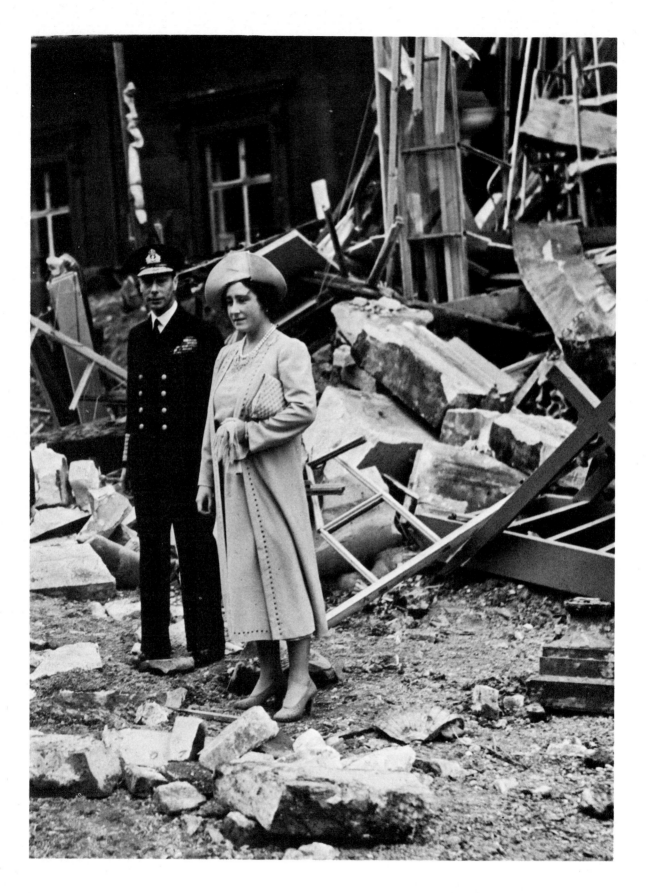

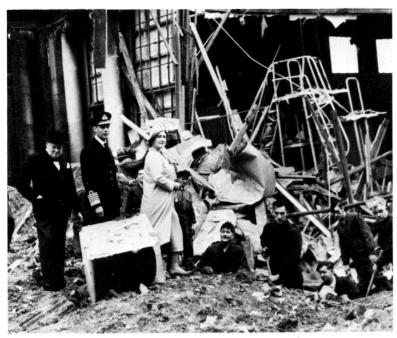

Opposite page
11 September 1940
Today the King and Queen viewed parts of Buckingham Palace which have been bombed, and personally thanked the Palace Air Raid Precaution staff for the way they handled the situation.
Left
A Speller 'scoop' – he was the only remaining photographer when Churchill unexpectedly joined the Royal couple.

Below
10 September 1940
Huge crowds followed Mr Churchill when he inspected the damage and bomb craters caused by last night's raid. Mr Churchill asked the crowd if they were down-hearted and cries of 'No' were heard from one and all.

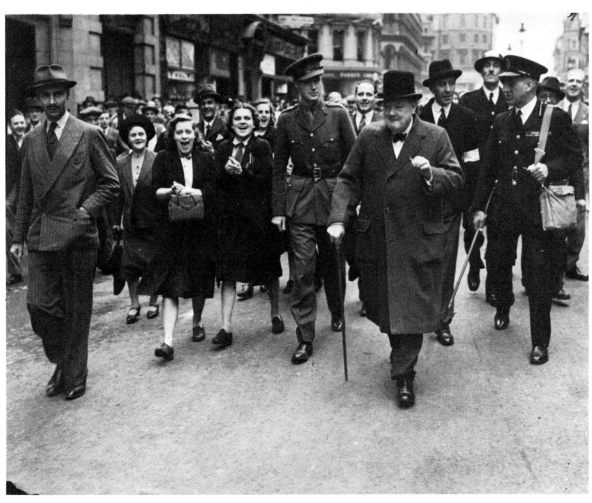

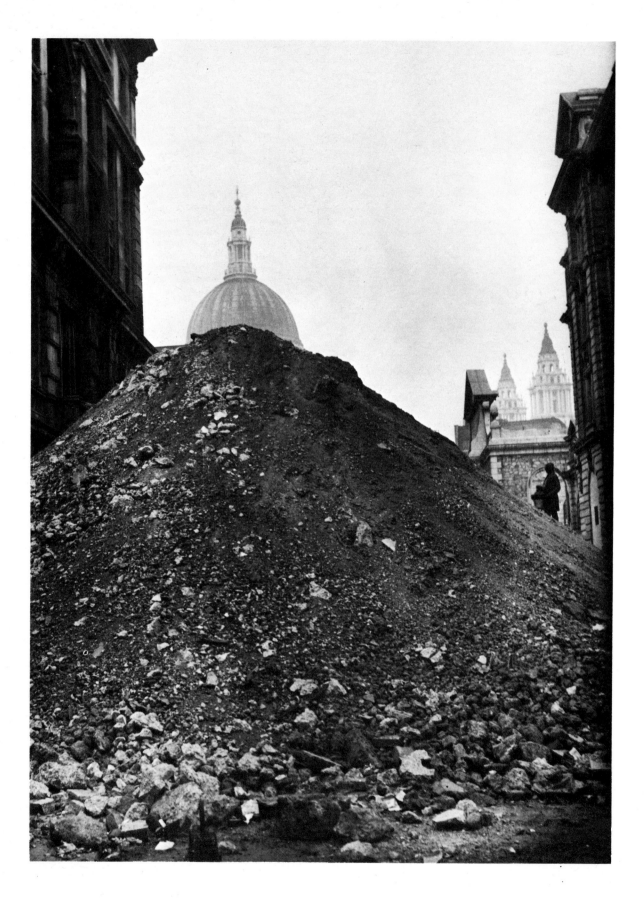

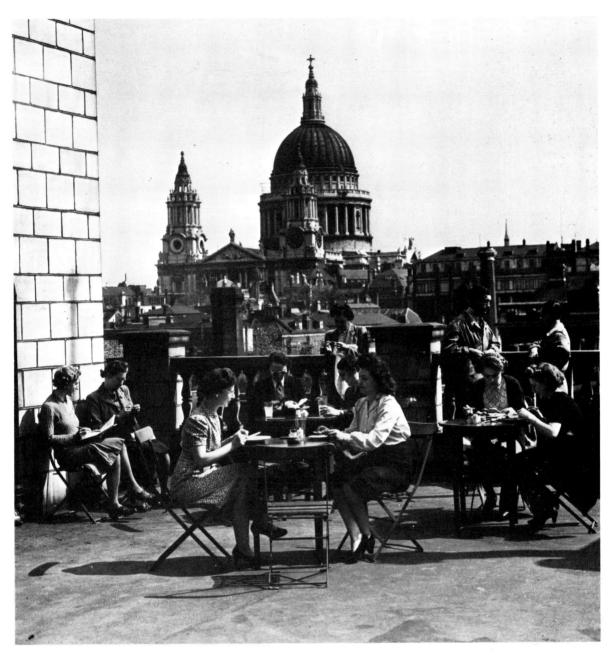

4 May 1944
City workers enjoy their luncheon
hour in the sunshine, with St Paul's,
which survived many air attacks, in
the background.

15 May 1941
St Paul's Cathedral barely visible
over an enormous mound of earth
thrown up by a Nazi bomb.

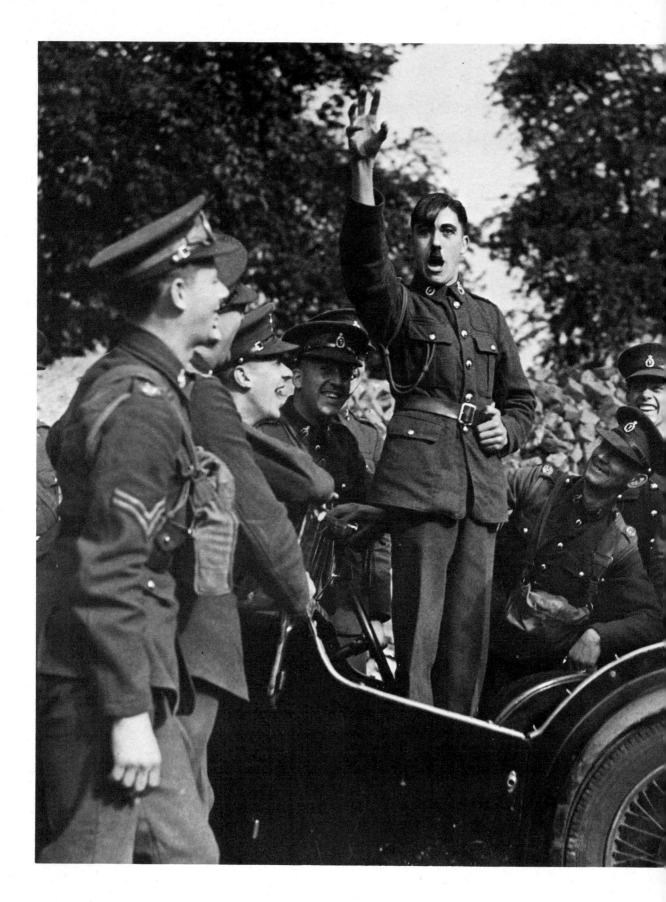

The War Effort

Speller remained at work in Britain for most of the war, recording events on what was known as the 'Home Front'. This included not only the well-known Home Guard (at first called the Local Defence Volunteers) but also the Anti-Aircraft Command, the women's Auxiliary Territorial Service, the Air Raid Precautions wardens, bomb-disposal units, munitions workers and many others. The front-line forces were also much in evidence: fighter pilots, servicemen home on leave or wounded.

Speller's brief was to convey the energy and enthusiasm of those on the Home Front. Our modern view of the muddled determination of the Home Guard owes more than a little to his pictures of them sprinting down suburban streets in their gas masks or diffidently eyeing a tommy-gun inside a railway carriage. There was still scope for holiday pictures with rows of waving girls; but now these were joined by rows of artillery shells with comic messages for Hitler.

There was a lot more to the Home Front than comedy. There was genuine drama, such as the survivor being rescued from the ruins of his bombed home, and Speller's most dangerous 'scoop' ever: recording the dismantling of an unexploded bomb which could have blown him to bits at any moment.

3 October 1939
A detachment of soldiers stationed in the Home Counties take a brief rest from training. Some of the men have taken up acting as a hobby. Here is one of their number in a dictatorial attitude, much to the amusement of his companions.
Overleaf
Some of them undergo their training in a street in SW London.

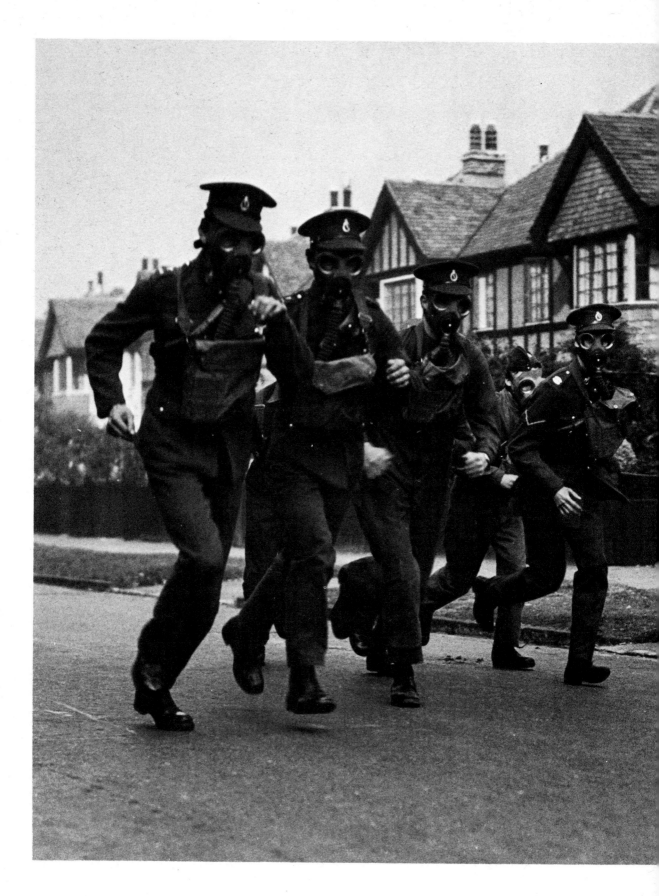

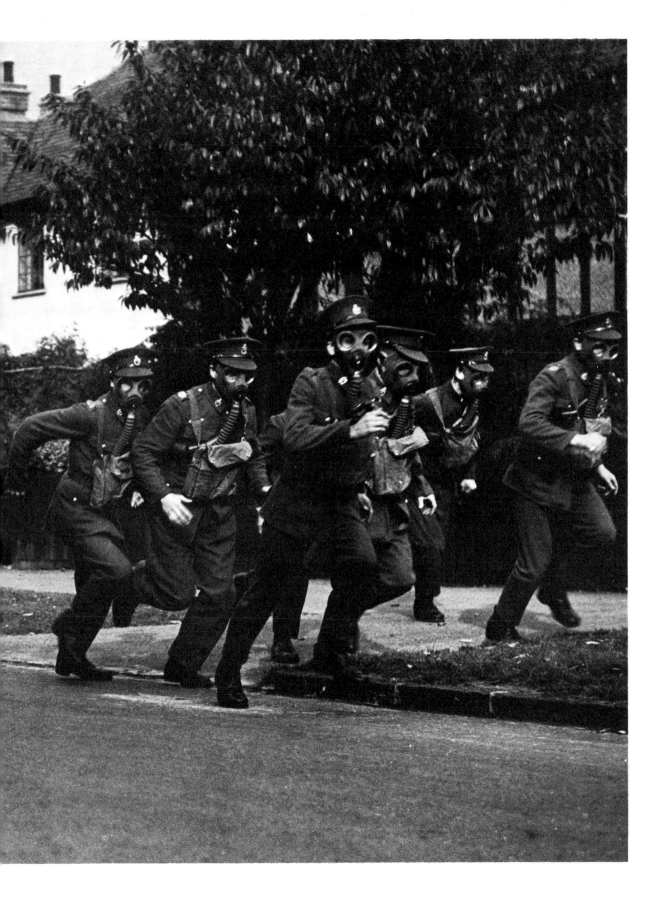

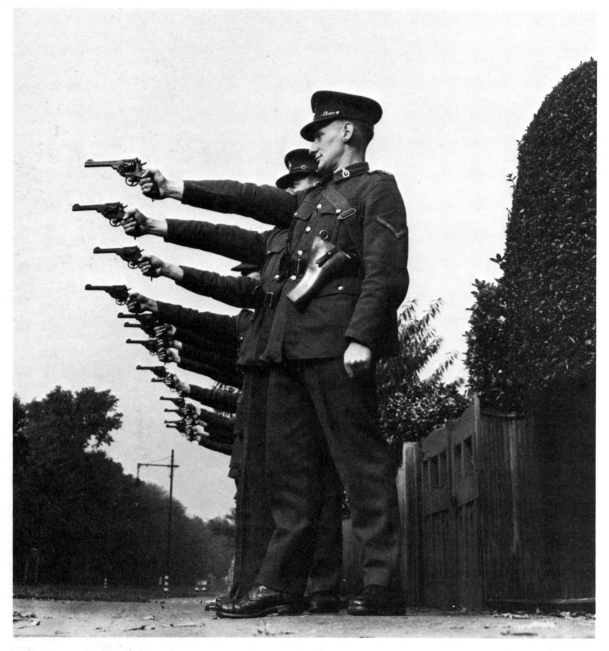

4 October 1939
This striking and unusual picture
was taken 'somewhere in London'
where these despatch riders are
undergoing revolver firing training.

11 March 1942
Tommy gun instruction for the
Southern Railway Home Guard
inside one of their coaches, which
has been equipped for them as part
of a training school. The curriculum
of the school will include instruction
in automatic weapons and grenades,
field exercises, unarmed combat and
guerrilla tactics.

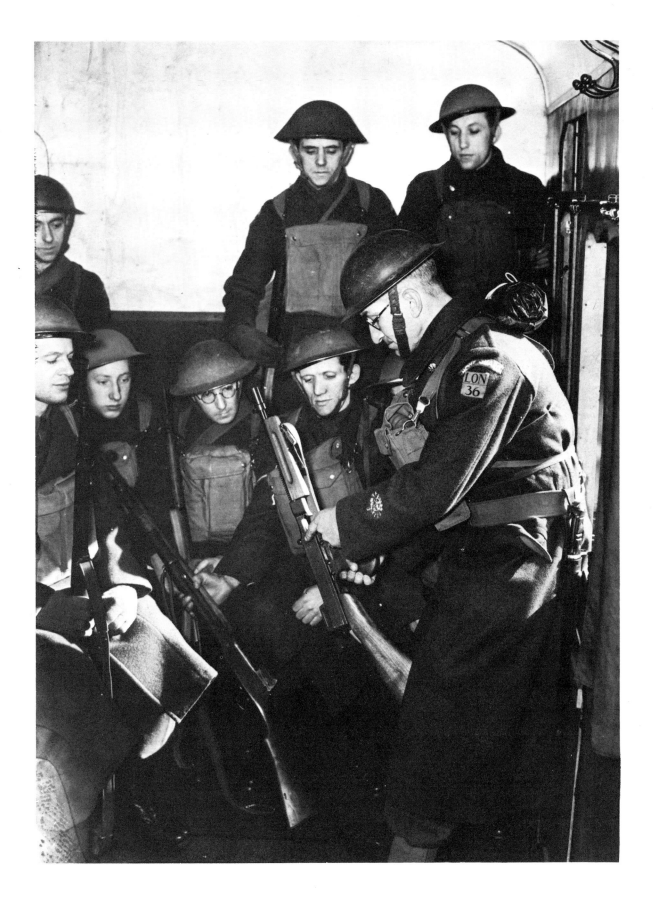

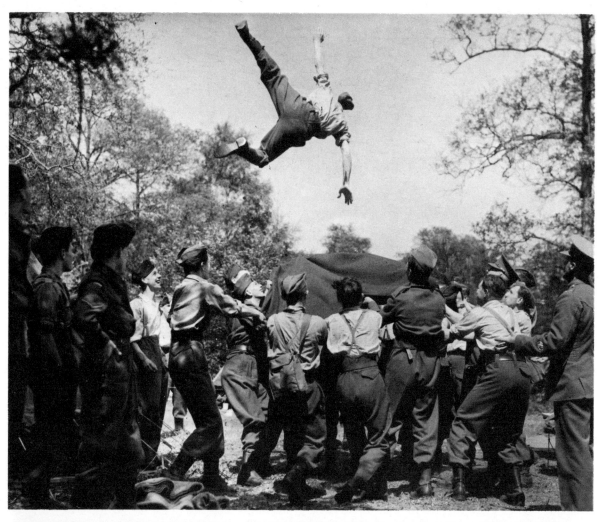

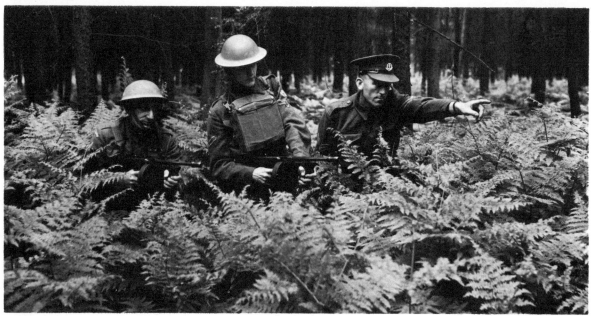

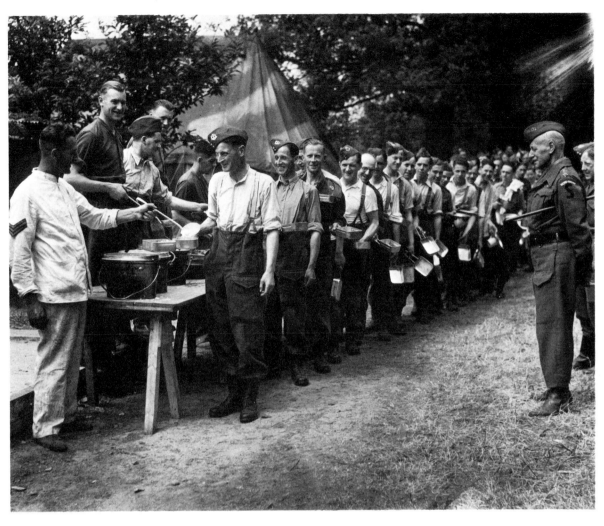

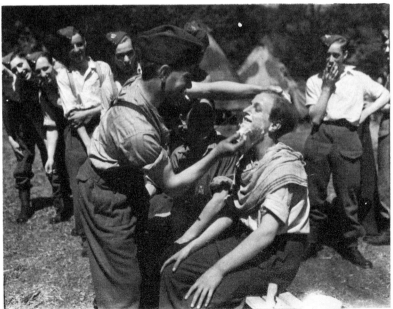

Opposite page (above)
19 July 1941
The time-honoured custom of 'Tossing in the blanket' is observed at the Home Guard Camp where members enjoy life under canvas while undergoing intensive training for the defence of Britain.
Opposite page (below)
They receive tommy gun instruction in the bracken around their camp.
Above
From the row of smiling faces at the camp the answer to 'Any complaints?' seems to be 'No'.
Left
Queuing up for the morning shave.

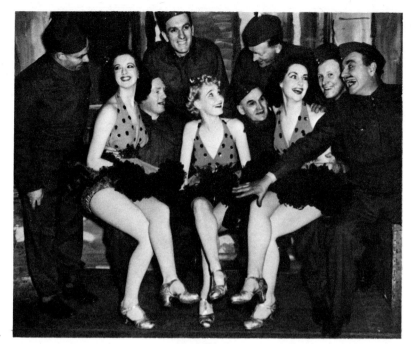

27 March 1940
Tommies make the acquaintance of
The Ascots during the interval at
Drury Lane Theatre this afternoon
where 2,000 members of the
Anti-Aircraft Command saw an
all-star ENSA (Entertainments
National Service Association) show.

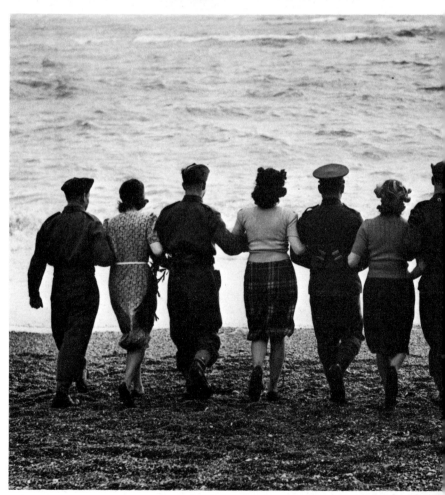

Right and opposite page (top)
6 April 1940
These soldiers made use of their
leave by joining the girls on the
south coast.

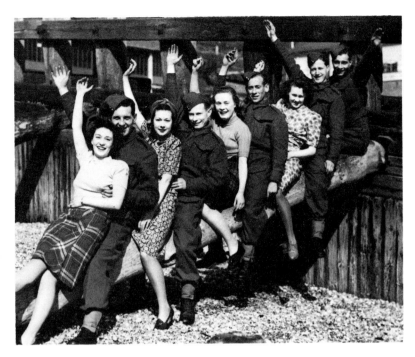

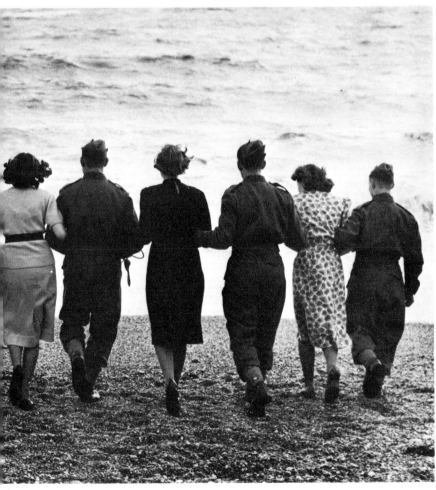

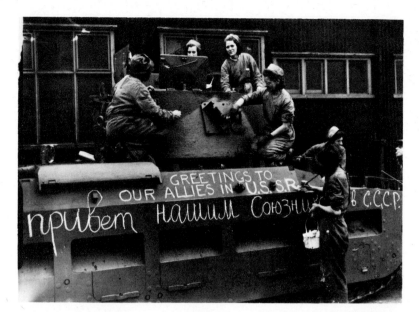

19 September 1941
Every tank and tank part made in Britain next week will be sent to the Russian battle-line. In a telegram from Lord Beaverbrook, Minister of Supply, to all tank factory workers, he appeals to them to do their utmost – saying that the tank factories of this country must supply the needs of Russia, whose soldiers are fighting in the same just cause.

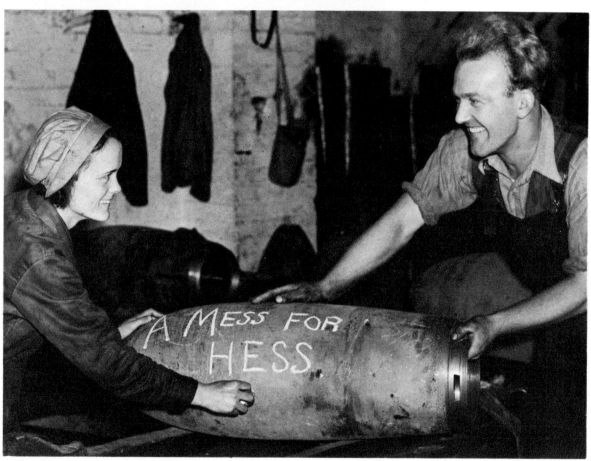

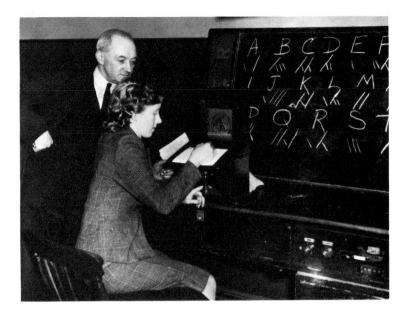

3 January 1942
Women are now taking over the job
of operating the telegraph machines.
Here a new operator receives
instruction in their use.

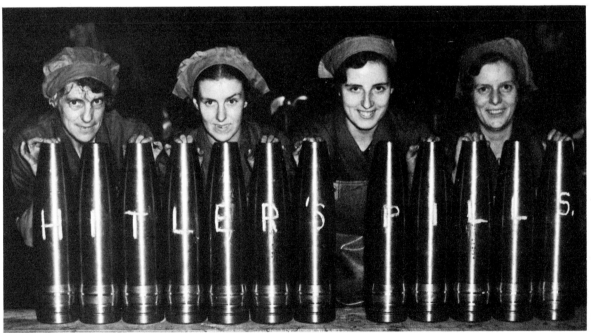

Left and above
19 October 1939
These pictures were taken at a vast
munitions factory 'somewhere in
England' where thousands of shells
and bombs, large and small, are
turned out daily. The spirit of the
workers is reflected in the facetious
messages frequently found chalked
on the shells and bombs.

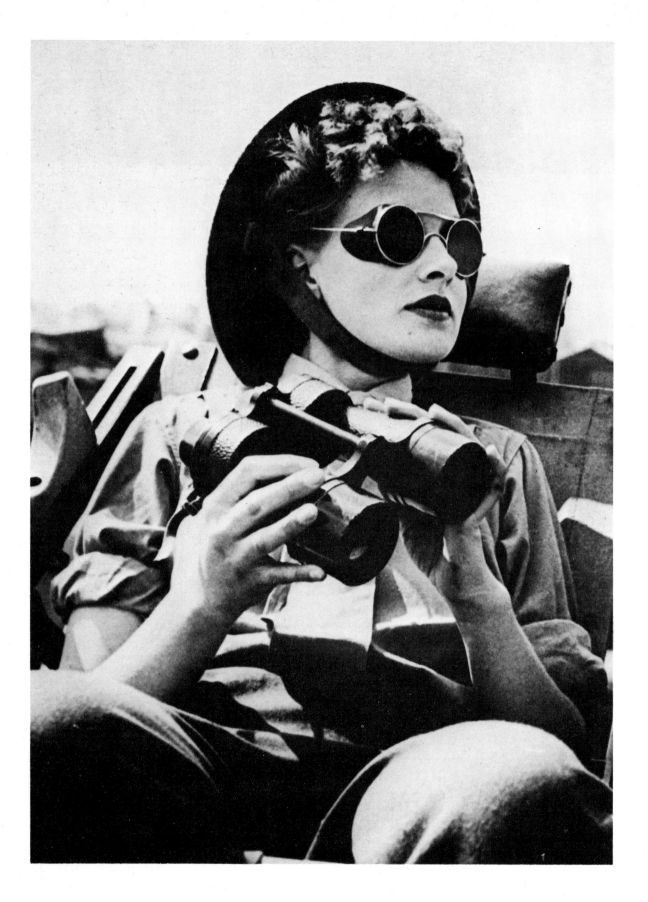

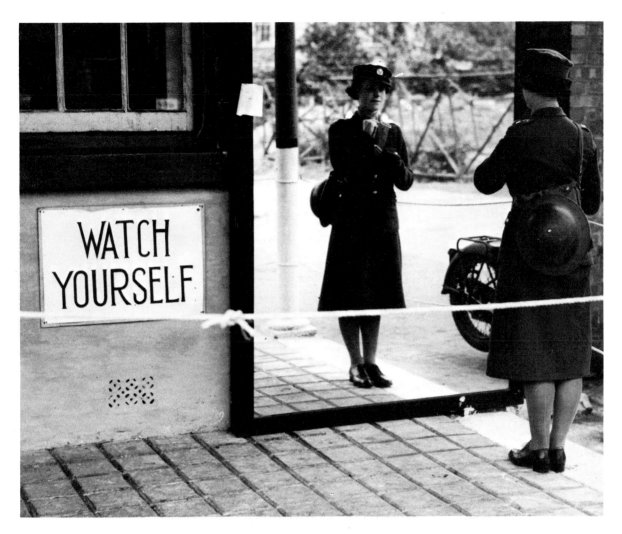

10 June 1941
An ATS visitor to an army barracks
inspects herself in a mirror which
has been set up for men to check
their appearances.

14 June 1943
Equipped with sun glasses and her
binoculars, Miss Parker, an ATS
(Auxiliary Territorial Service)
Spotter of enemy aircraft, on
constant duty at an Anti-Aircraft
site near London.

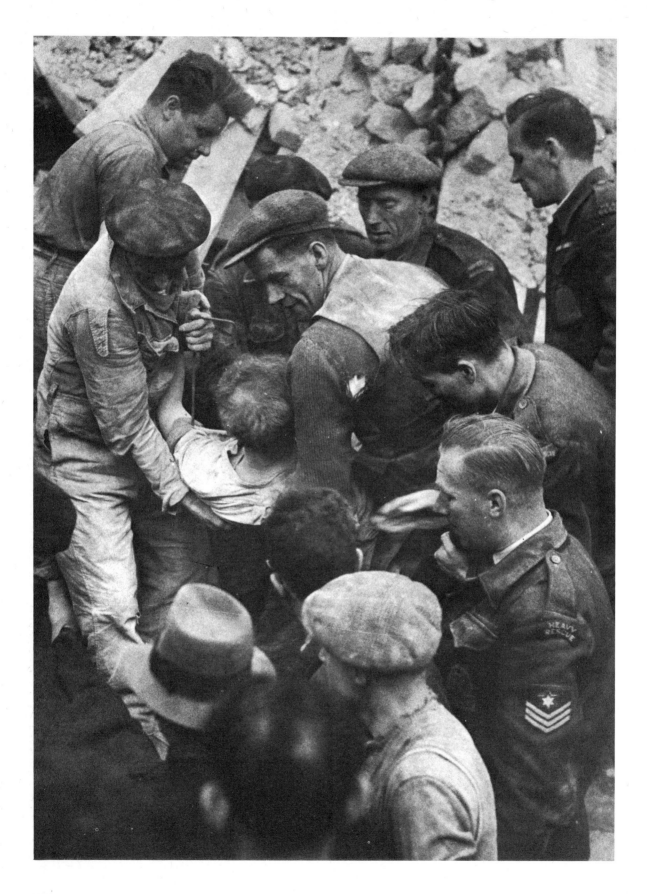

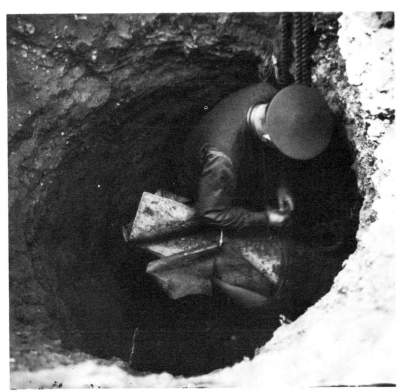

Opposite page
18 October 1943
ARP wardens retrieving a man who
has been buried in the debris of his
bomb-damaged house for 13 hours.

Left
20 September 1940
A bomb disposal unit under the
command of Lieutenant Davies, set
about retrieving and defusing a
1,200 lb bomb which a Nazi plane
had dropped in the grounds of a
hospital in London. Here
Lieutenant Davies starts on the
delicate task of fixing tackle to lift
the bomb out of its deep crater.
Below
As his men hoist the bomb out,
Lieutenant Davies stands on the
nose in order to lever its base away
from the ground.
(This assignment, as dangerous for
the photographer as it was for the
bomb disposal men, was a Speller
exclusive.)

Overleaf
9 January 1941
A 'scramble' to awaiting Spitfires.

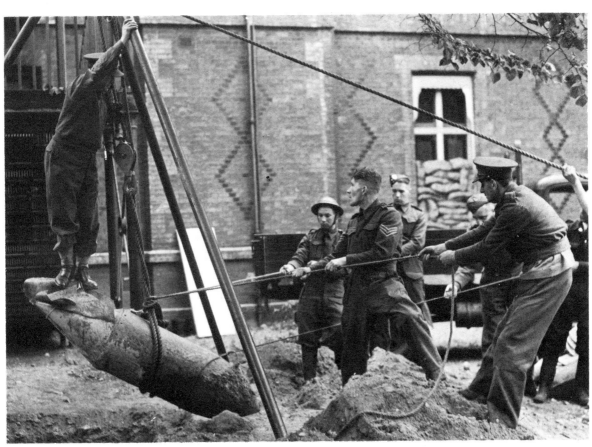

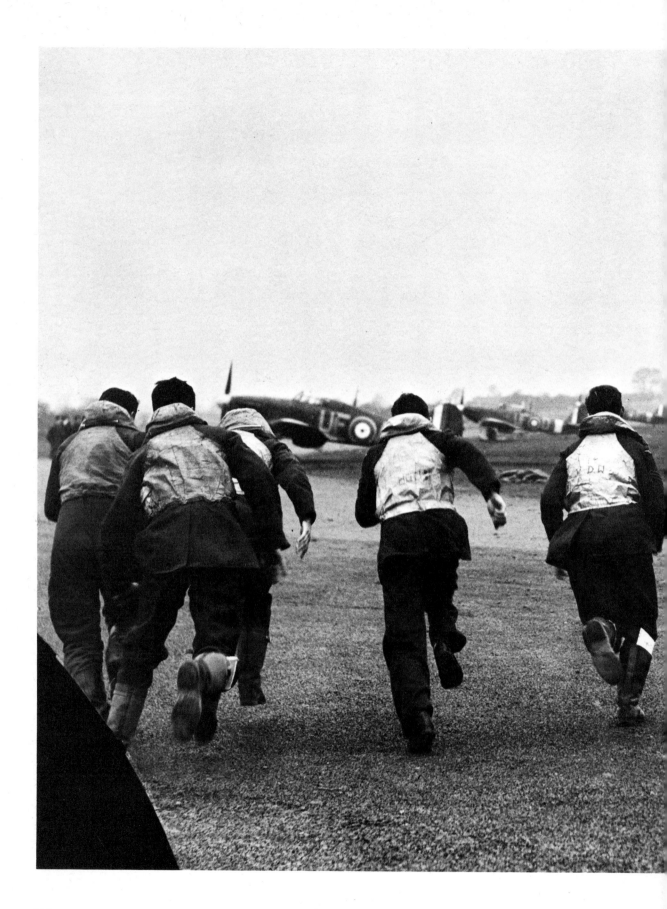

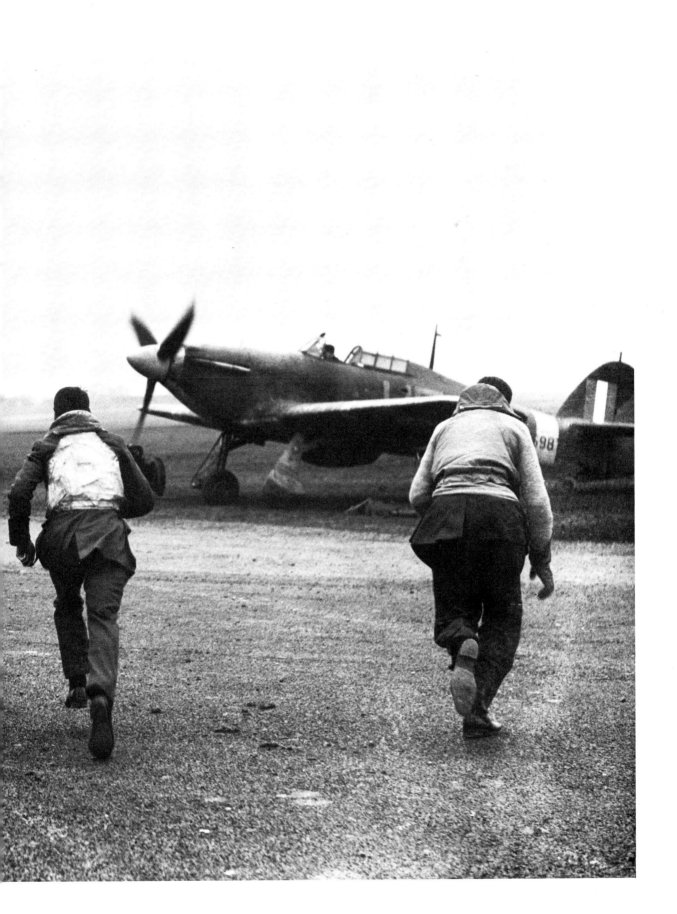

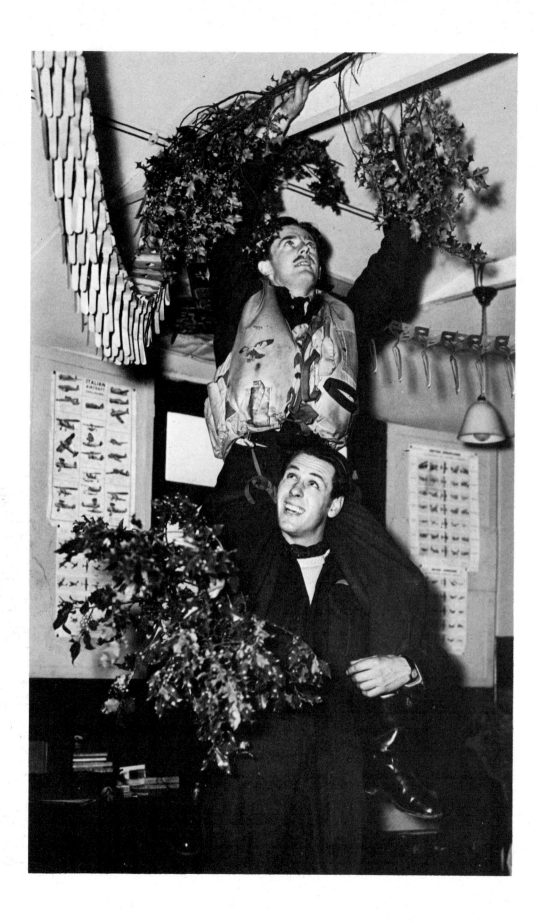

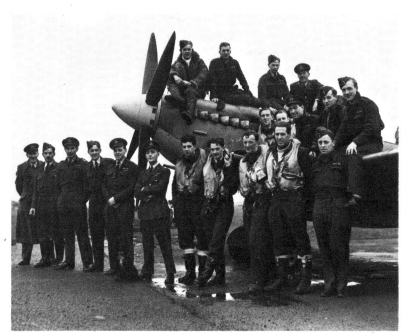

Left
22 December 1942
A quiet moment for RAF's No. 11 Group who are famous for their part in the Battle of Britain days.
Opposite page
Between their many patrols the station manage to find time for the usual Christmas decorations.
Below
Assisted by the Women's Auxiliary Air Force they are making sure that all remaining on duty between spells of action will sample the joys of Christmas. Here a WAAF decorates the pilot with holly before he leaves.

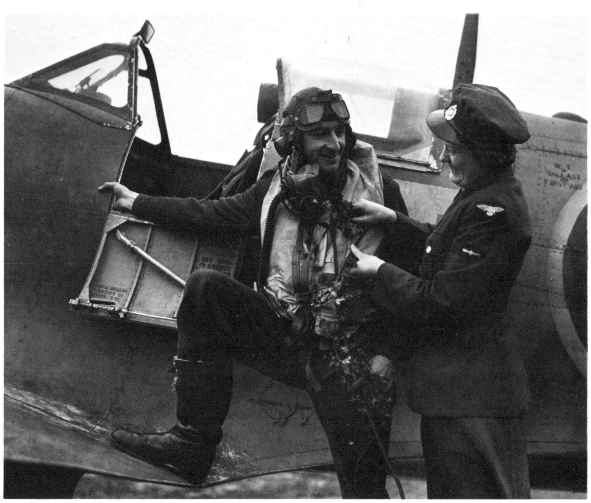

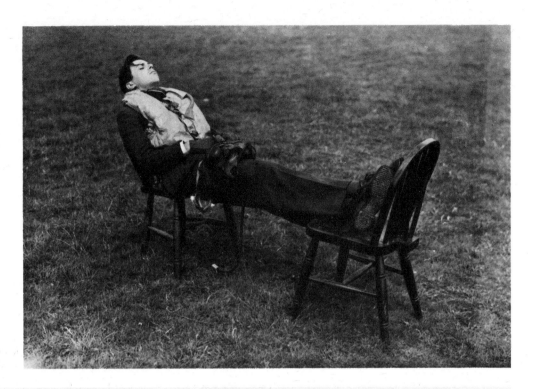

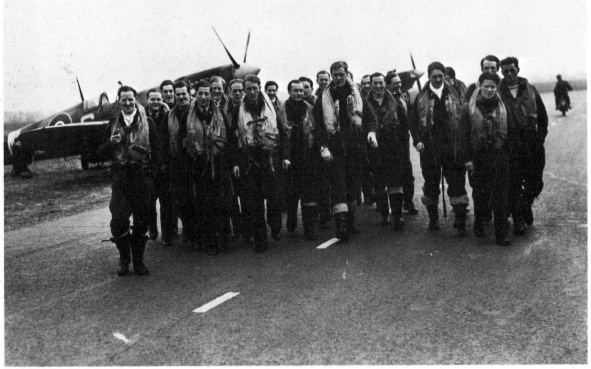

Top
15 December 1942
A pilot, who has returned exhausted from a difficult mission, takes a nap in the grounds at base.

29 March 1944
First pictures (*above and opposite page*) of the New Allied Expeditionary Air Force which now forms the spearhead of attack of the Fighter Force of the RAF. Here pilots make their way back to quarters after leaving their planes. This squadron has destroyed 86 enemy aircraft and severely damaged more than 70. It belongs to a wing which has flown more than 1,000 sorties since 1 January.

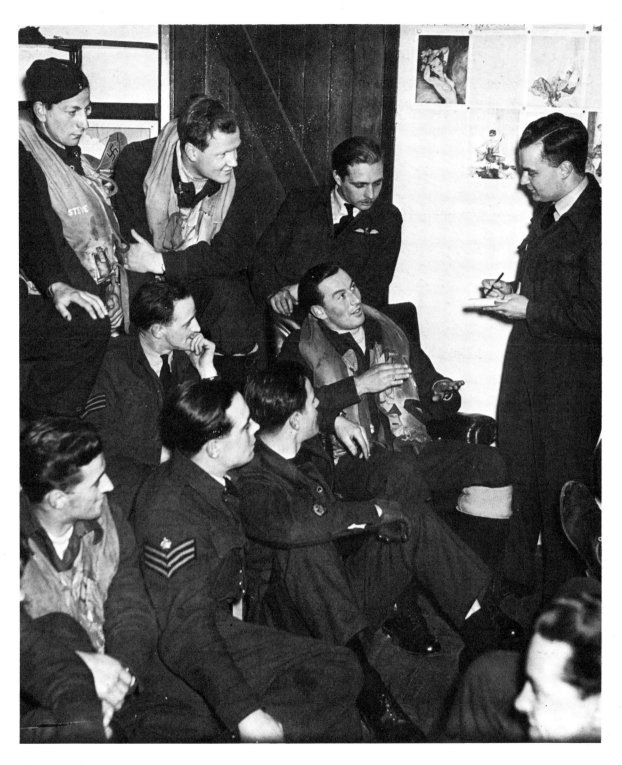

11 April 1944
Flight Officer Nobes interrogates a
member of the crew on his return
from an air attack.

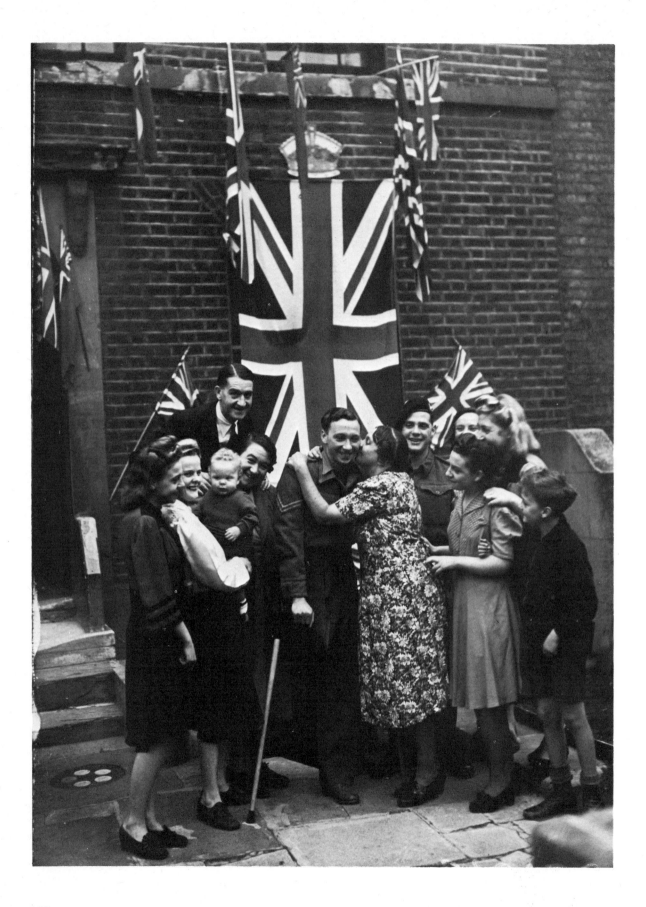

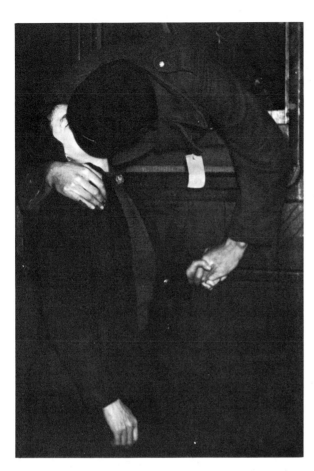

Opposite page
27 September 1944
Corporal Sam Turner comes home. His mother is seen kissing him and relations give him a hearty welcome. They decorated the house with flags. He has been in the Army for three years. He spent seven months as a prisoner of war; his leg was seriously injured during the Anzio Beach-head fighting, and was later amputated.

Left
26 October 1943
The girl porter in the Home Counties rushes to kiss Corporal Anderson from York, one of the boys who arrived back from Germany this morning.

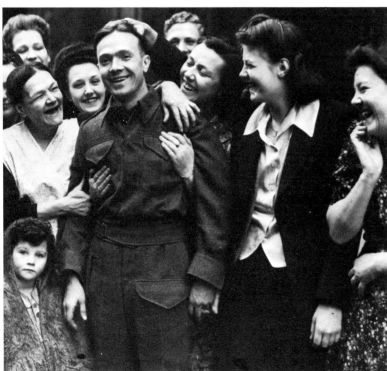

8 February 1945
Private Fred Poulten, a repatriated prisoner, arrives home at Clerkenwell and is given a hero's welcome. He has been a prisoner of war since Dunkirk, in the same camp as his brother who, however, is still there. All the street turned out to give him a welcome.

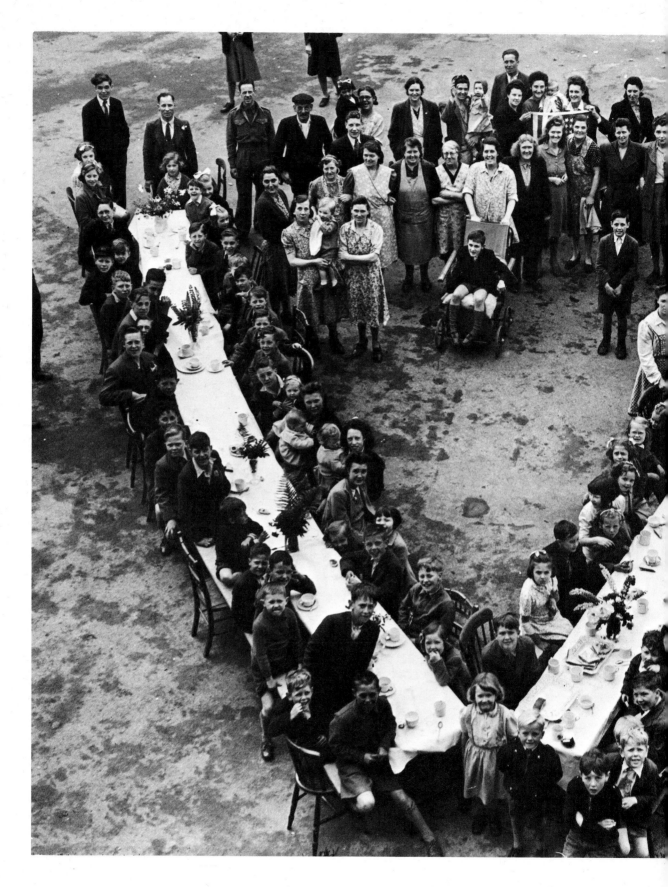

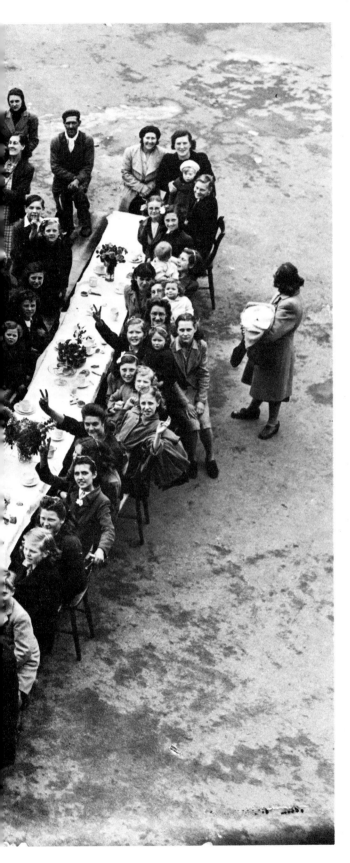

Victory!

Germany surrendered on 7 May 1945. This was officially announced in Britain the following day: VE Day, for Victory in Europe. The Royal Family appeared on the balcony of Buckingham Palace before jubilant crowds. On 15 August Japan's surrender brought more celebrations, with VJ Day. The official Victory Day parade took place in London on 8 June 1946. Twenty-one thousand people of all fighting and civilian services took part, watched by a crowd of six million.

Speller, by now a veteran photographer of state occasions, took his usual fine pictures of the formal ceremonies, from Queen Elizabeth in one of her famous hats to this unusual aerial shot of a Victory Tea at a V-shaped table. But there was much more to the rejoicing than that. The chilly marble of the Victoria Monument in the Mall swarms with spectators. A man climbs a lamp post in Piccadilly Circus. Did Speller send him up there as a 'stunt', or was it spontaneous? A flag seller outside Buckingham Palace waits for the news of Japan's surrender to be made official before he starts hawking his wares. And the last picture – even if it was posed – captures the real elation of victory.

31 May 1945
300 Camberwell children sit down to a special Victory Tea in the playground of Brunswick Park Schools, Camberwell, where they are waited on by their parents.

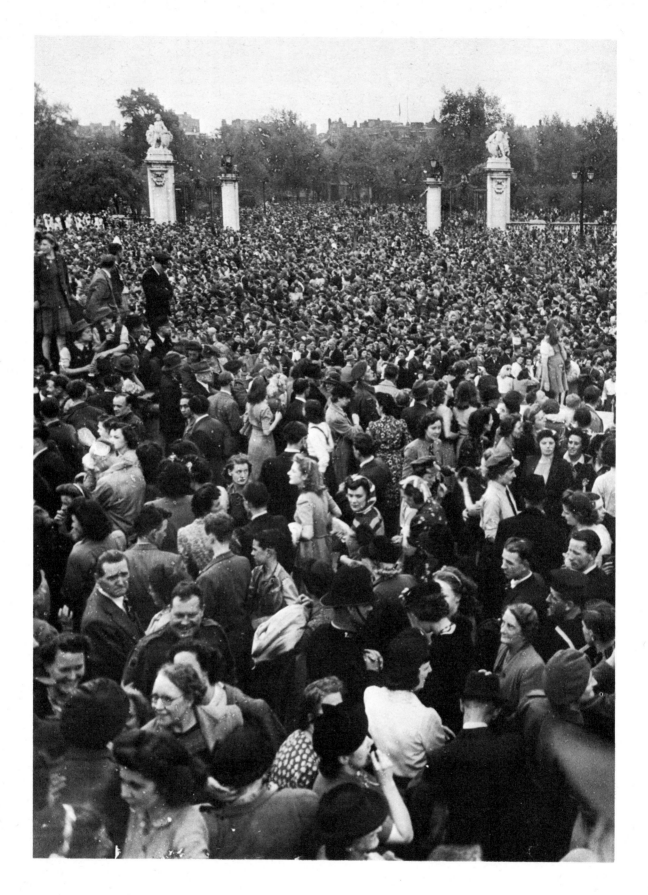

120

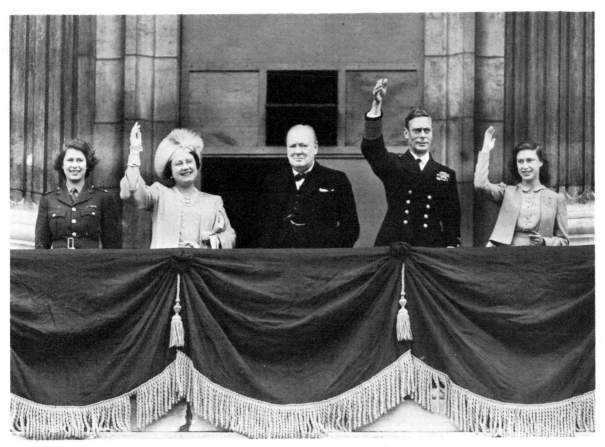

Left
8 May 1945
The crowds waiting for the Royal
Family to appear on the balcony of
Buckingham Palace on VE-Day.
Above
Princess Elizabeth, Queen
Elizabeth, Winston Churchill,
George VI and Princess Margaret
greet the crowds below.

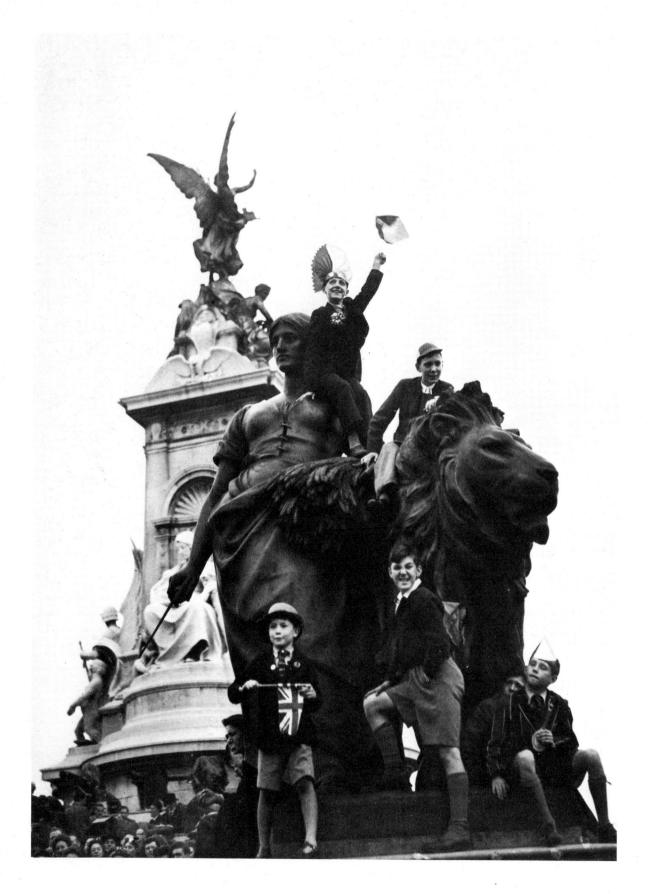

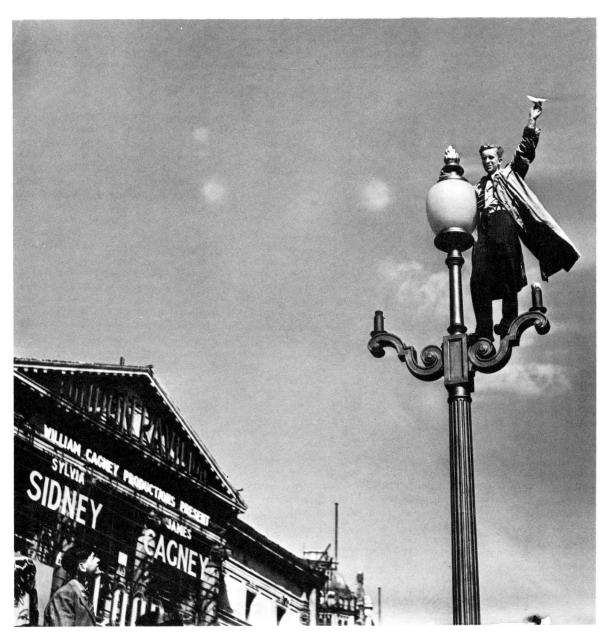

15 August 1945
VJ-Day and a man celebrates
Japan's surrender by scaling a
lamp post in Piccadilly Circus.

8 May 1945
The statues in front of Buckingham
Palace become perches for the
crowds gathered there on VE-Day.

14 August 1945
On the eve of VJ-Day a vendor
outside Buckingham Palace, with an
armful of flags, waits for the great
news to be made official.

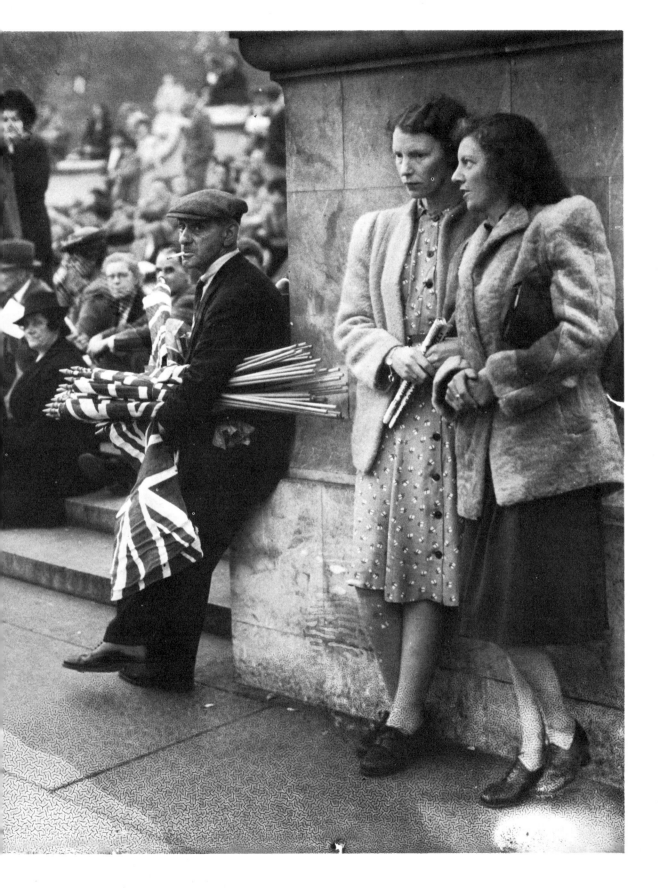

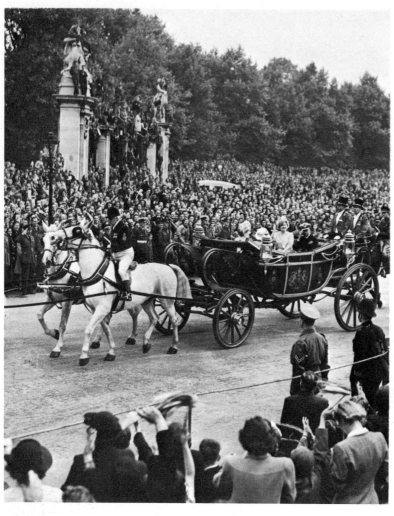

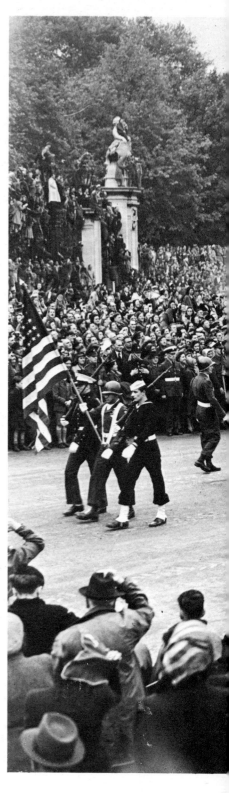

8 June 1946
A general view as their majesties,
the King and Queen, with the two
Princesses left Buckingham Palace
for the saluting base at the Victory
Day Procession.
Right
American servicemen in the
Marching Column en route for the
Saluting Base.

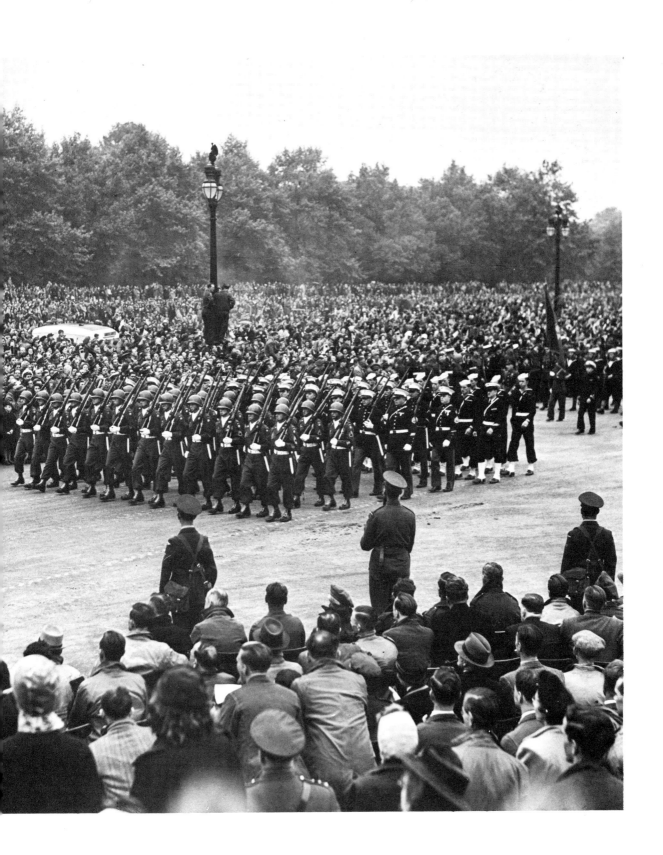

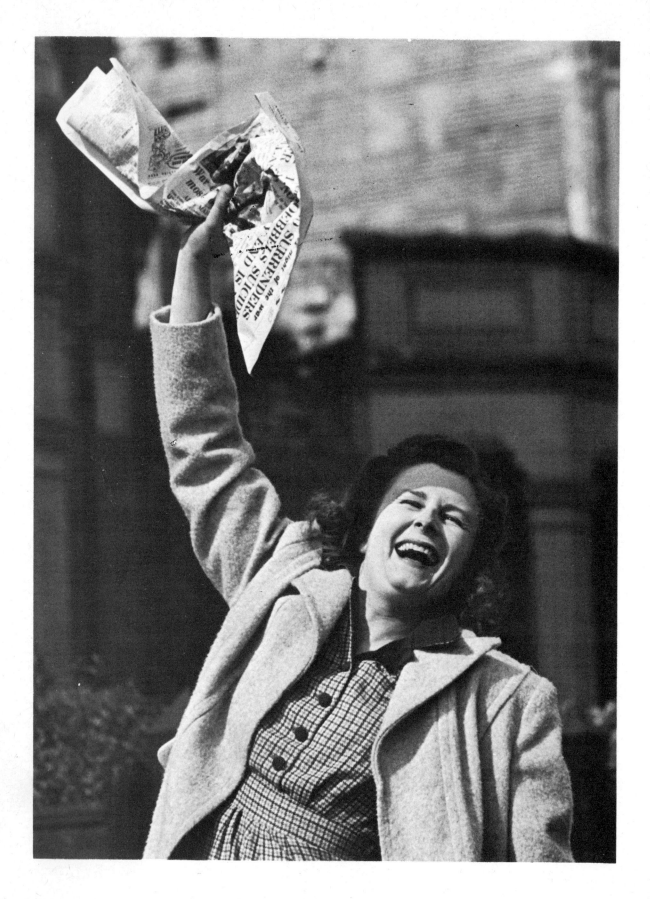